Thank you so much for buying this book!

I finally feel accomplished that creating this is complete! I've pushed myself every night losing substantial amounts of sleep to meet my own deadline. I wished that I had help with creating this but with much research, I figured out most of it. It may not be the most perfect but I attempted to make it very unique! I'm sure it'll be a great way to stimulate your creative side and give you a peace of mind. The most exciting part about this process is getting to see how you all color my artwork. Eager to see the mandalas created with the templates! Please like the page I've created for the book and feel free to post your finished designs and anything else you want. fb.me/Bendalacoloring facebook.com/bendalacoloring Instagram #bendalacoloring

I hope that you enjoy the line drawings I've created!

Contact info

http://www.instagram.com/orphan_of_thought

www.facebook.com/bensancheztattooer

erblerbl.bs@gmail.com

- Copyright @ 2016 by Ben Sanchez. All rights reserved

Here are some examples of how you can use the grids.

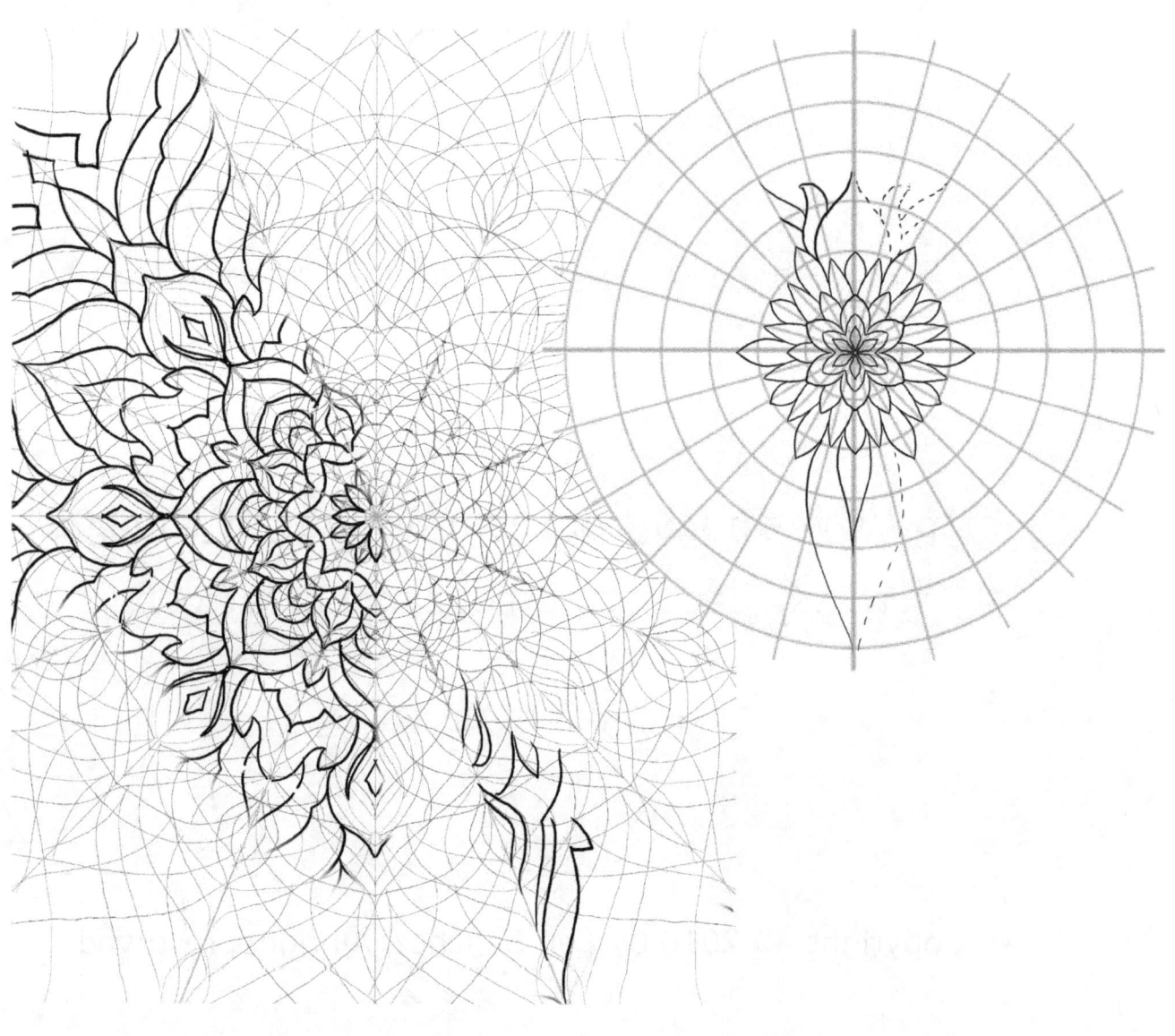

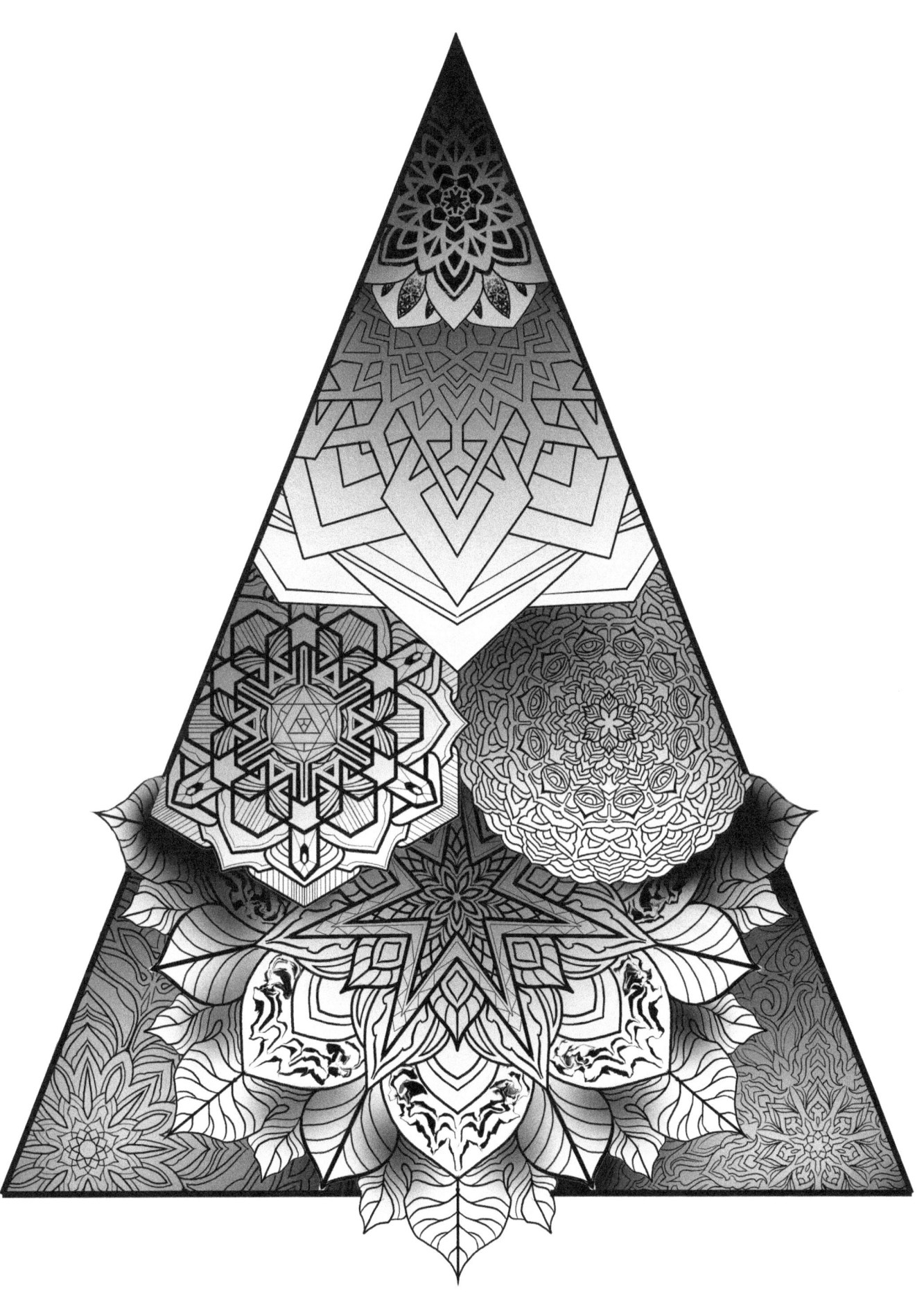

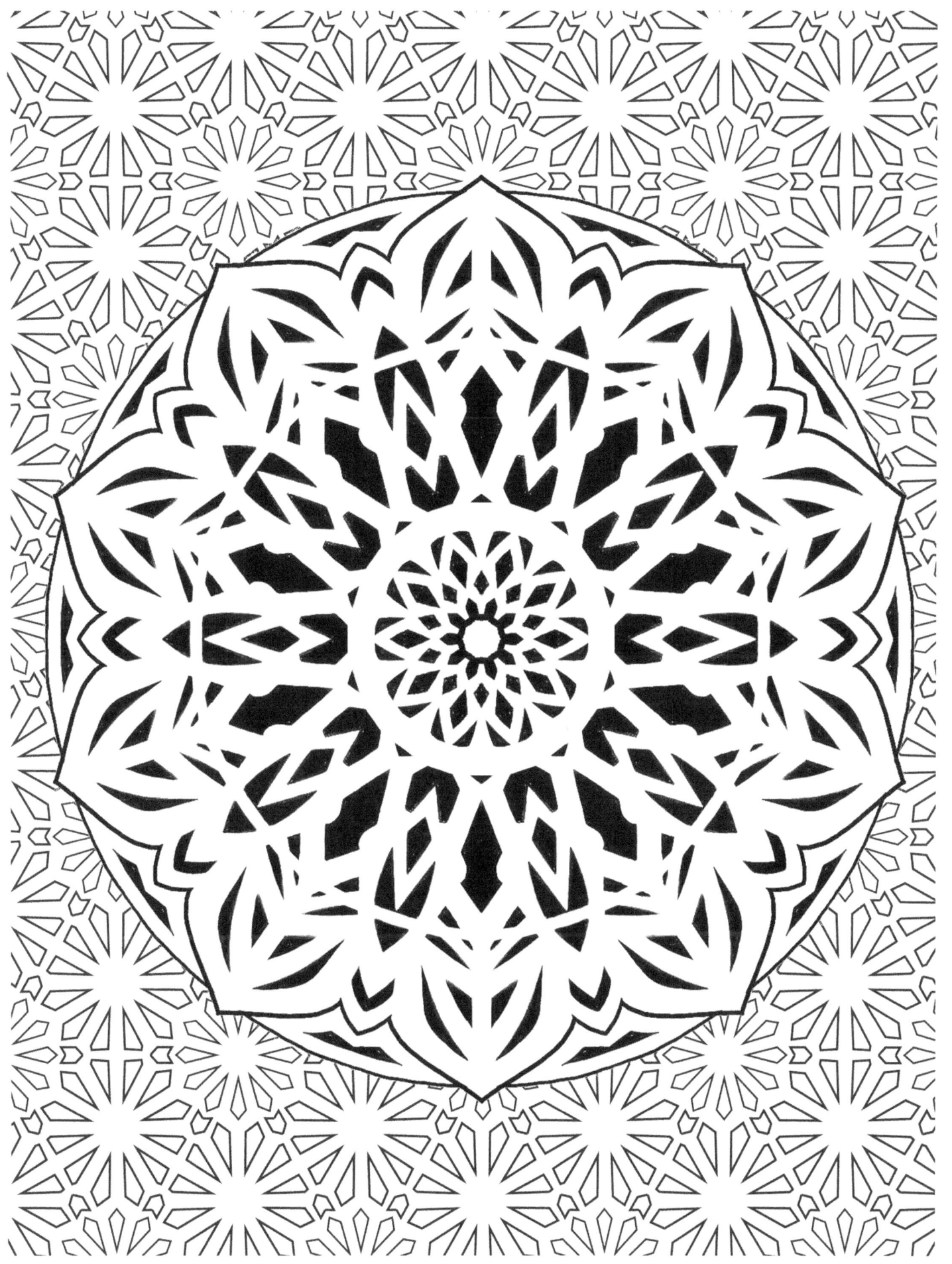

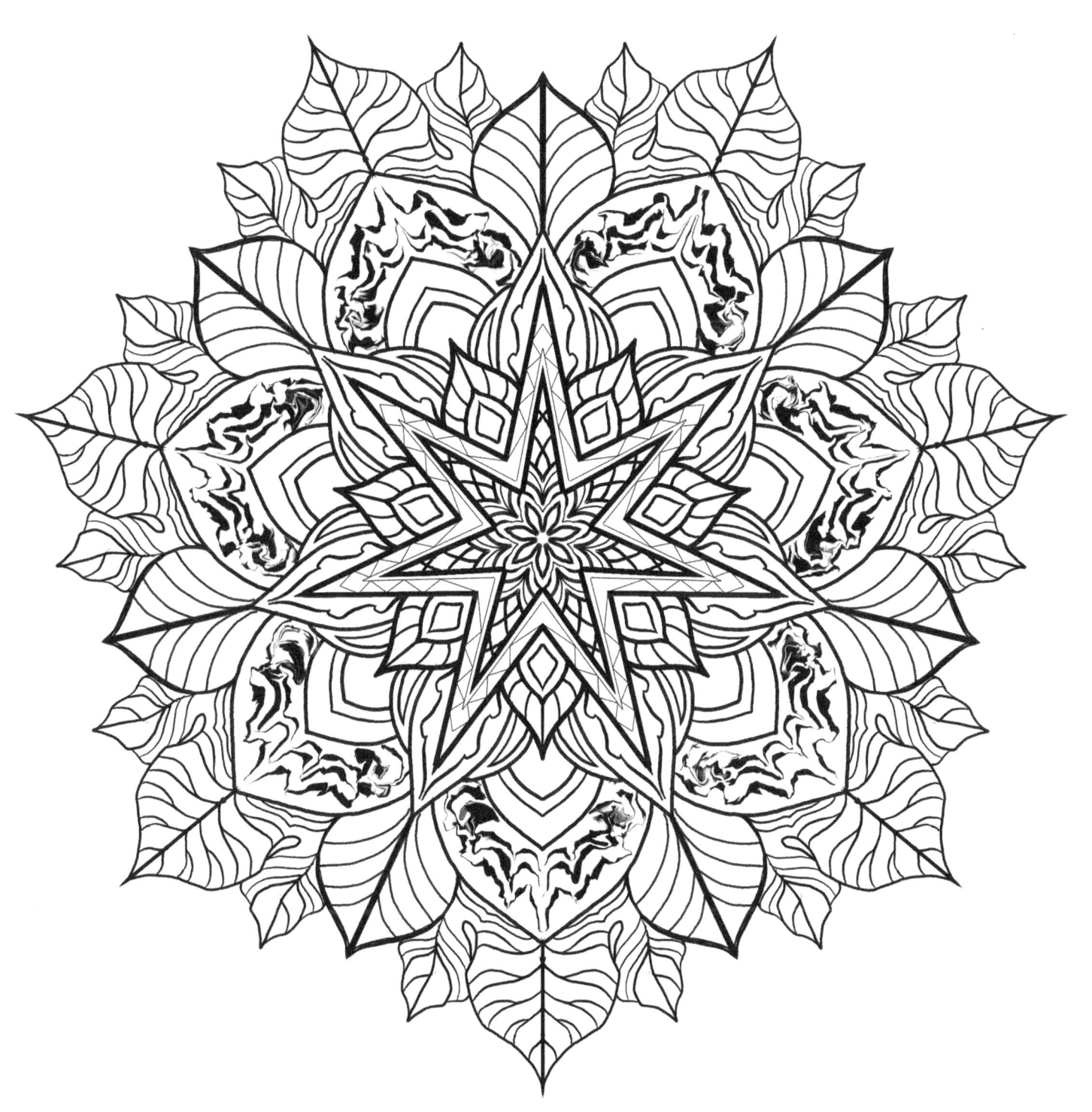

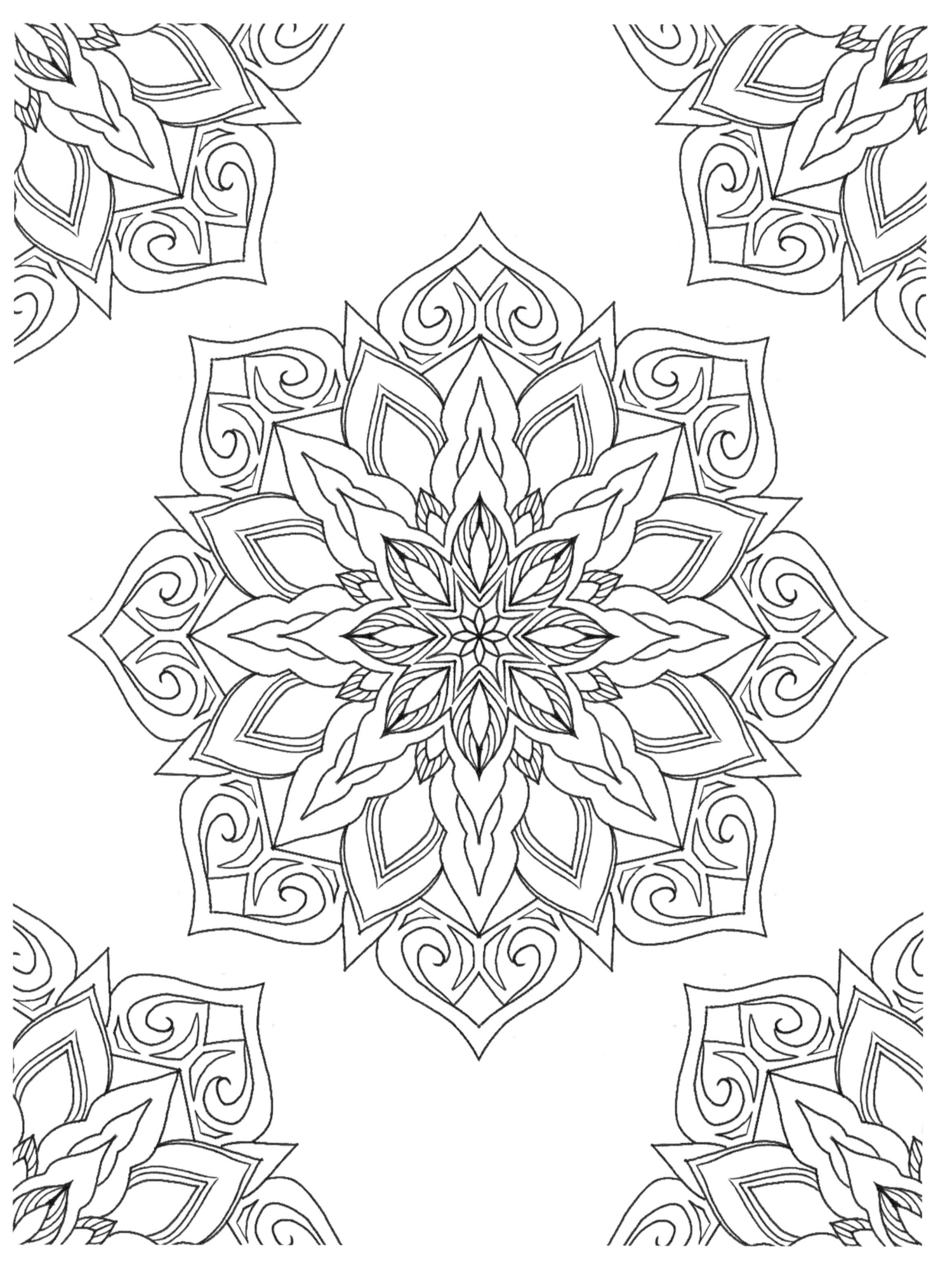

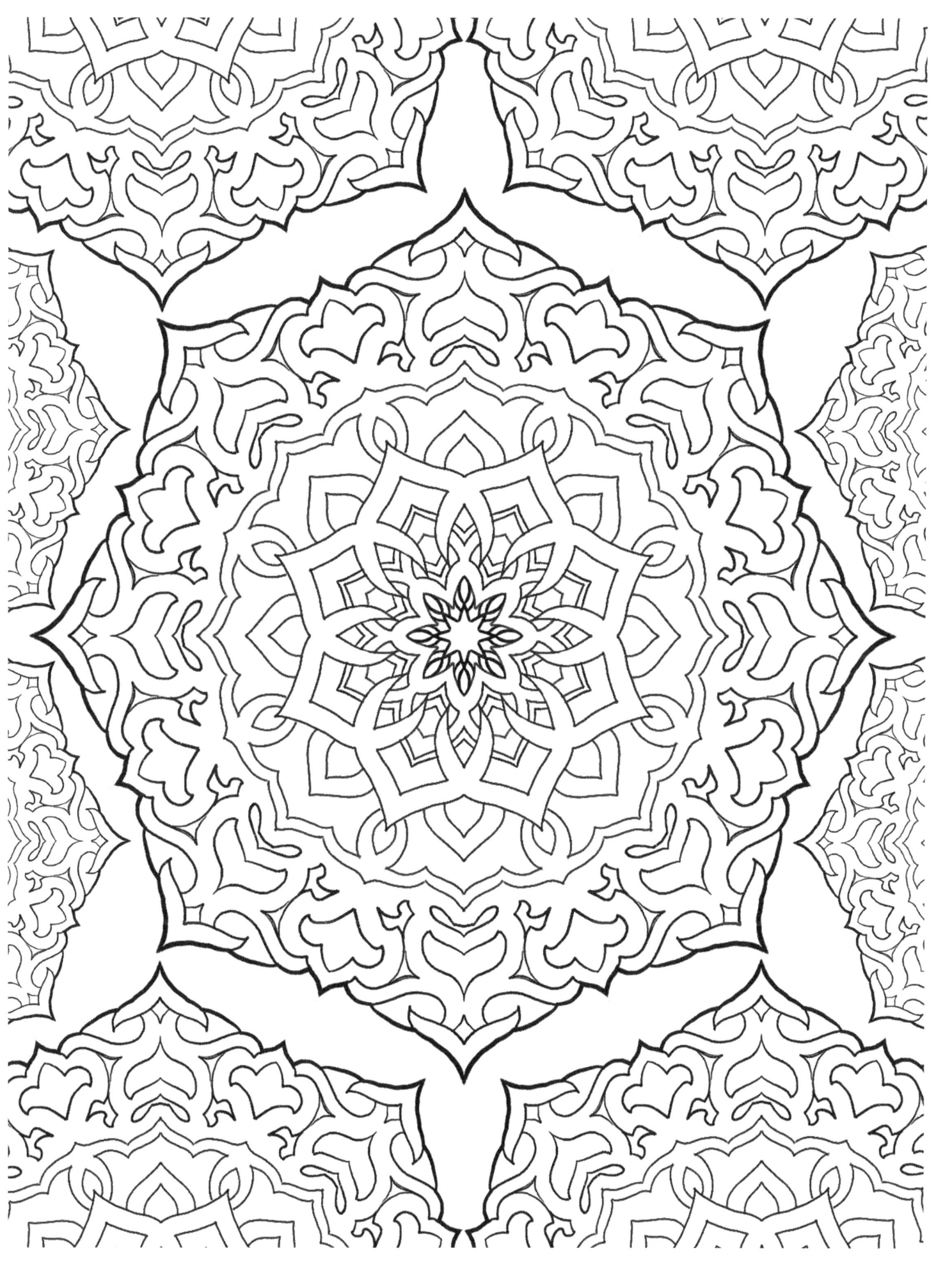

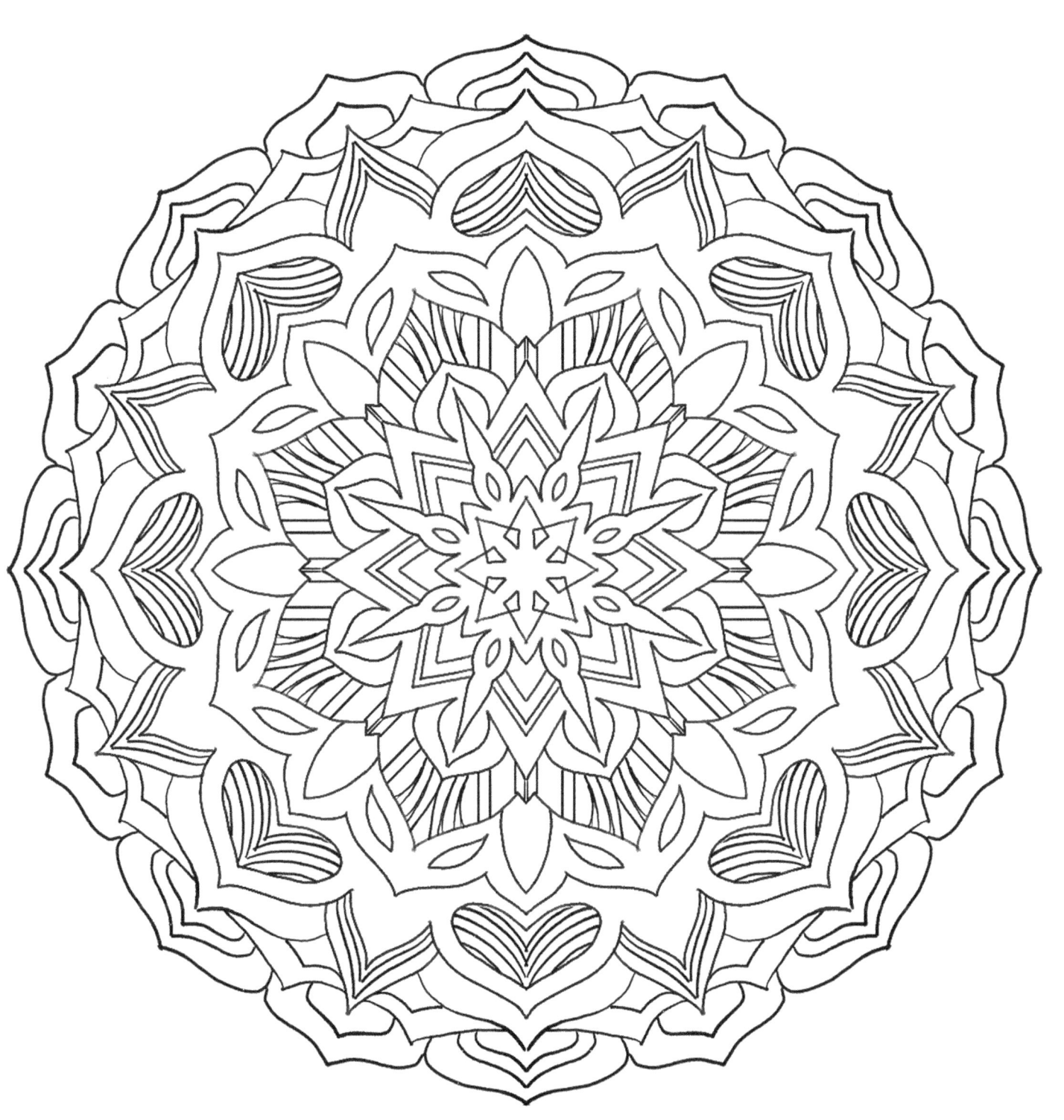

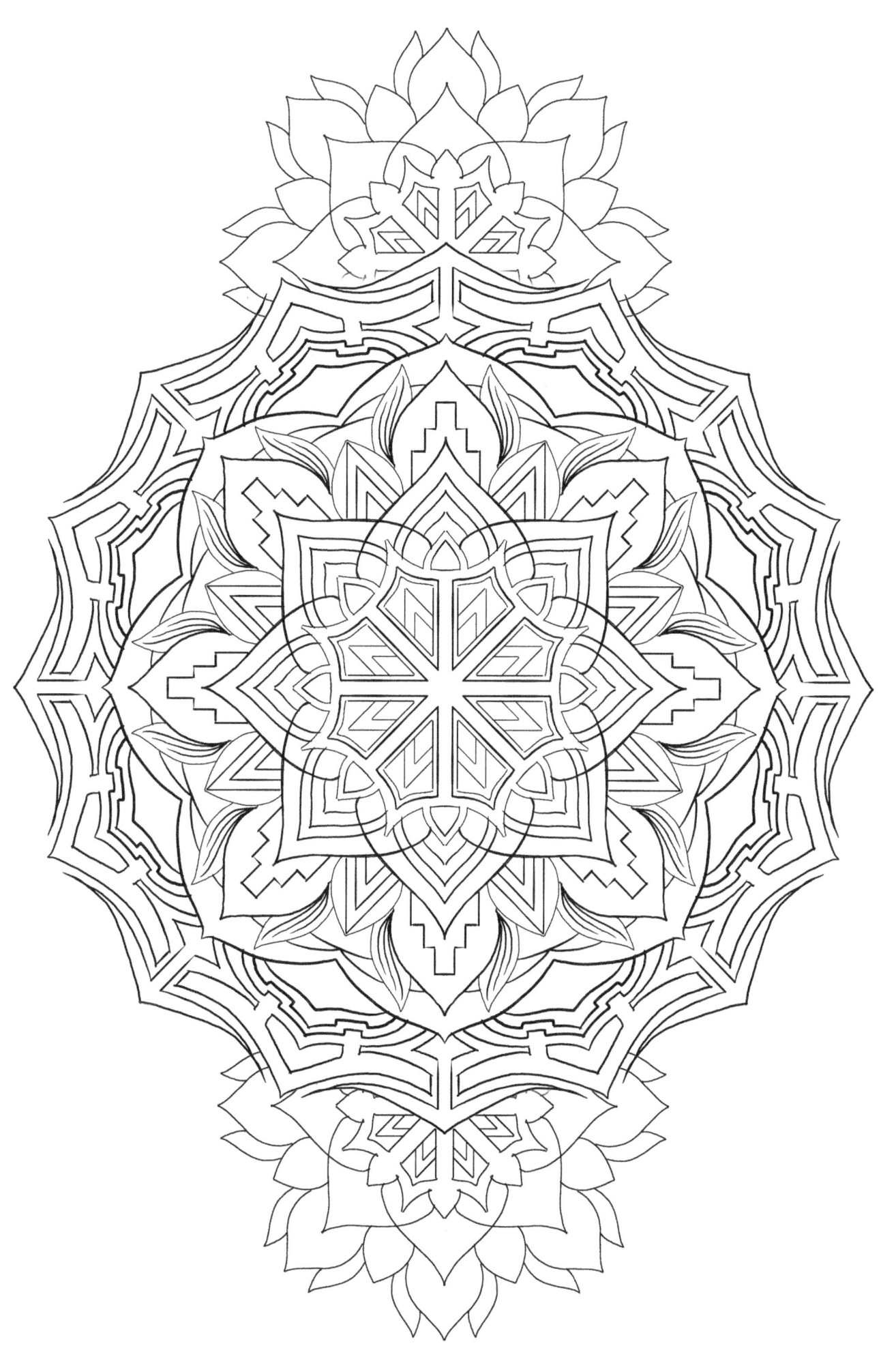

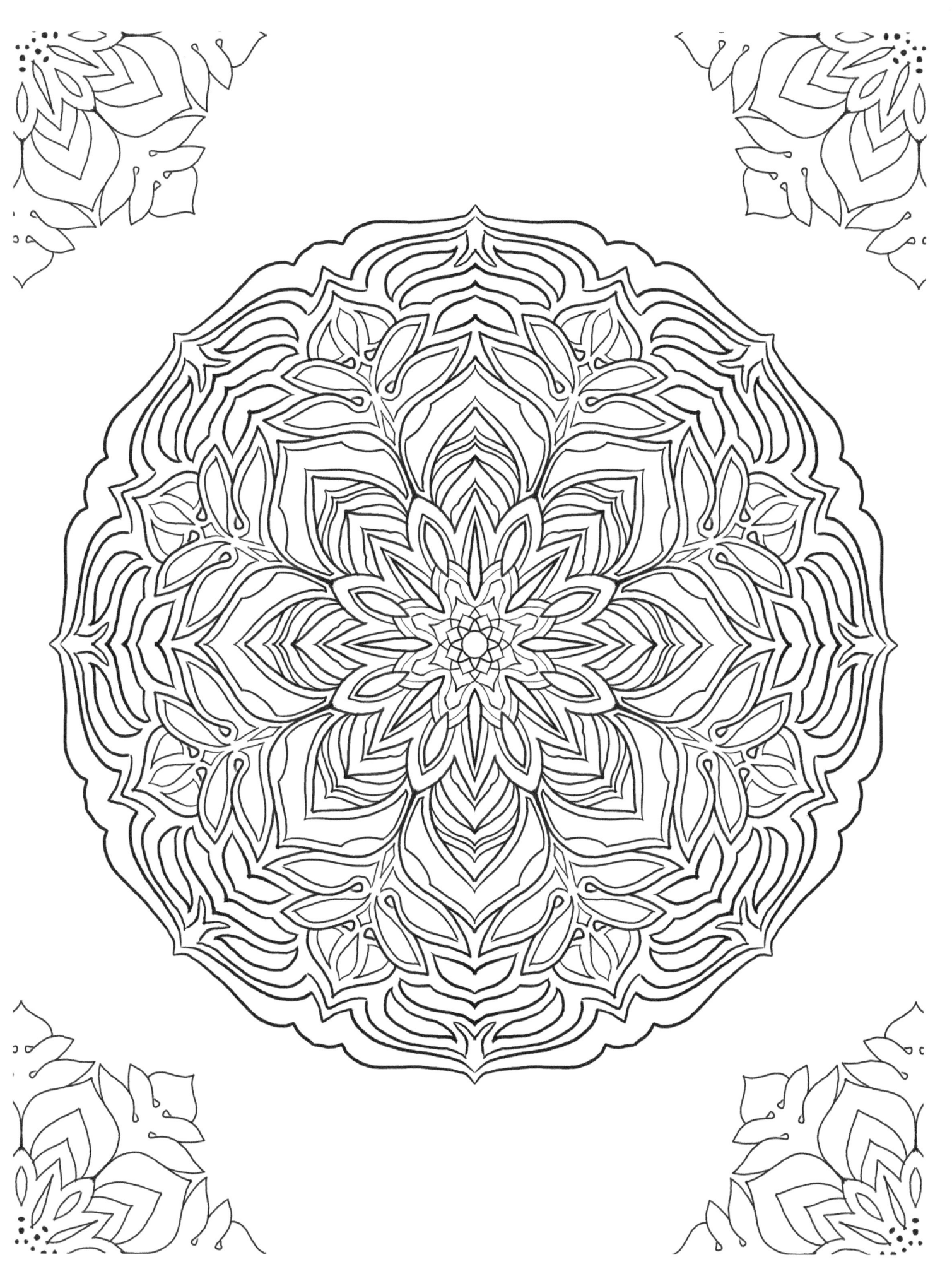

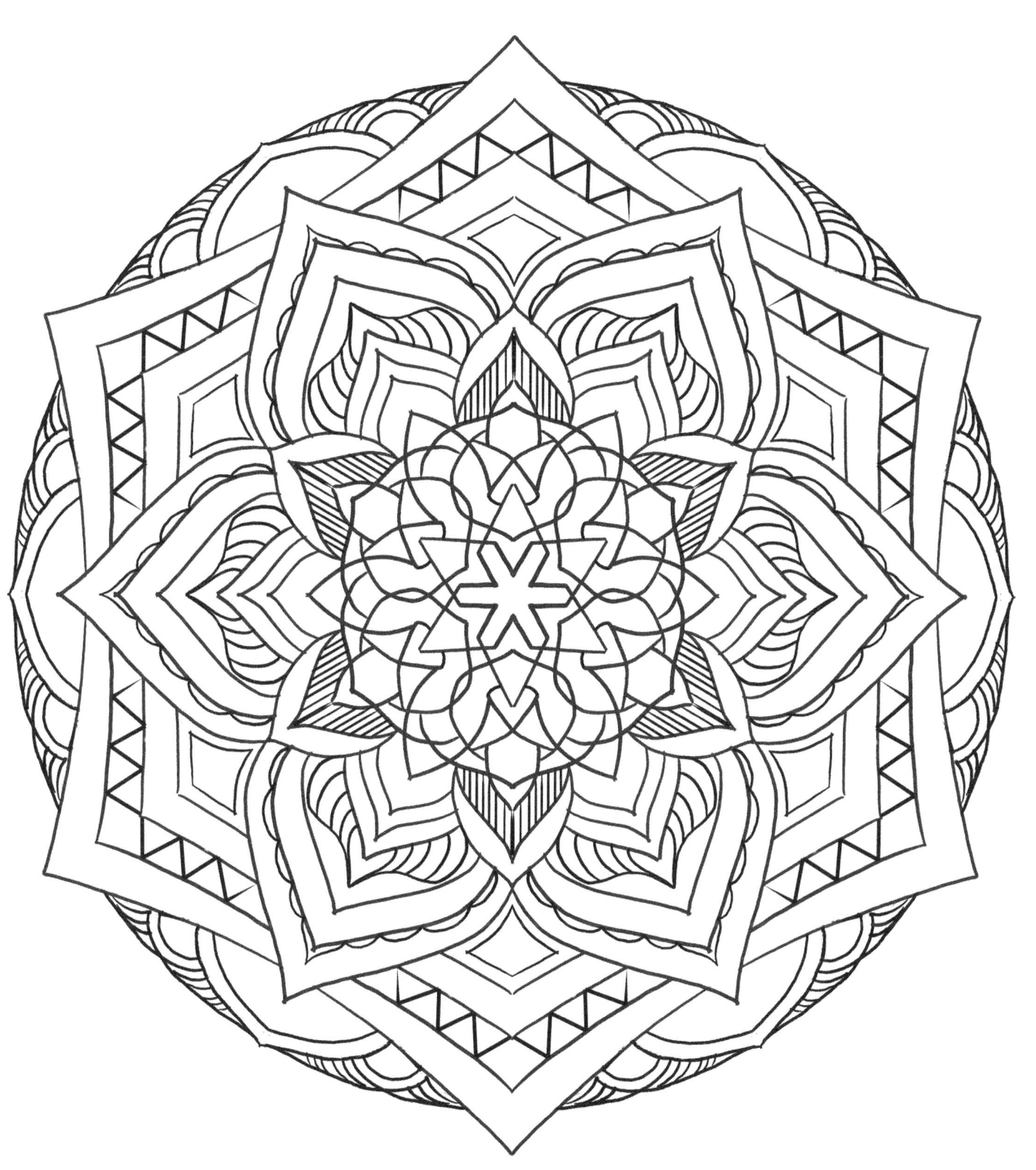

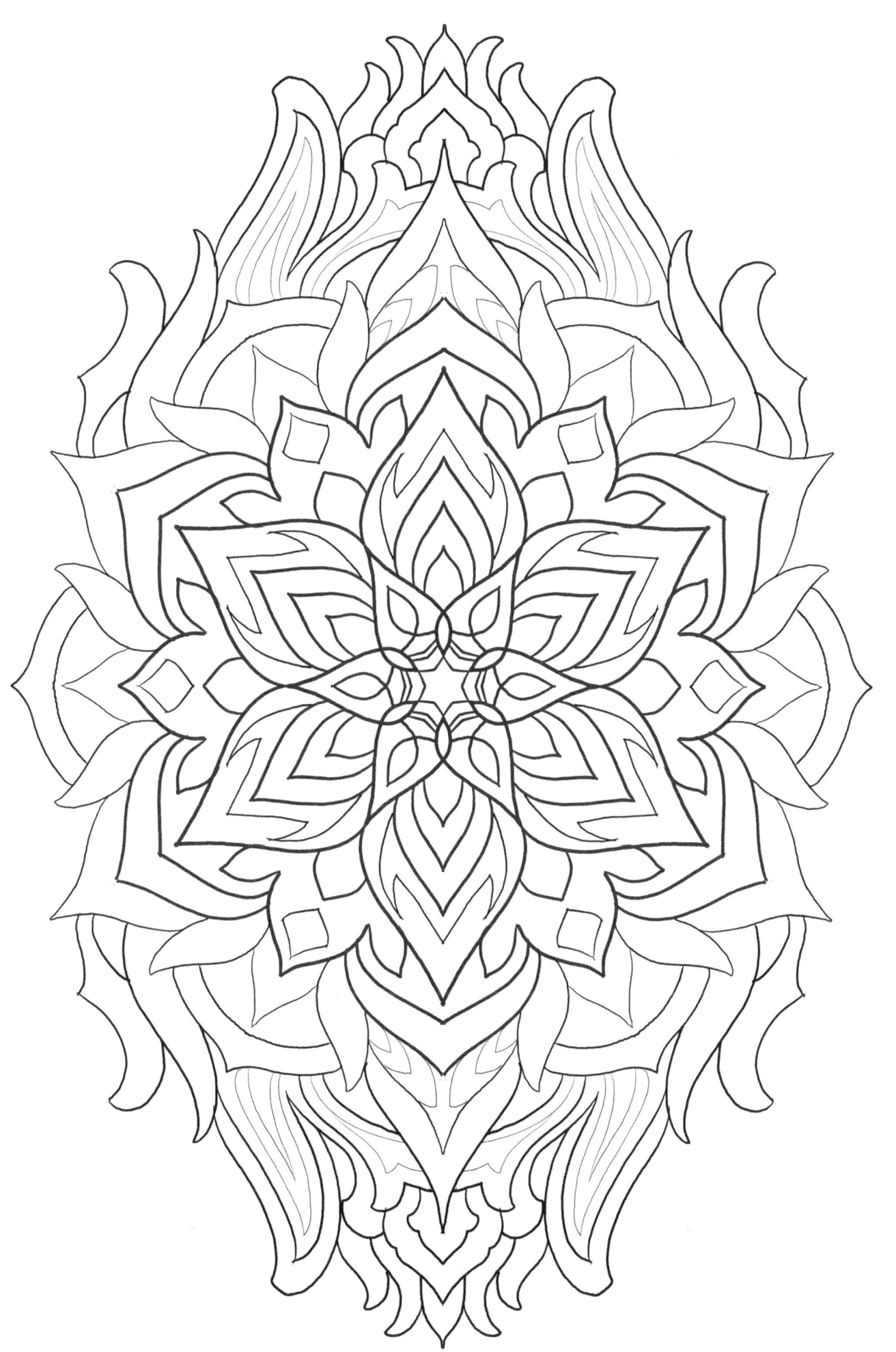

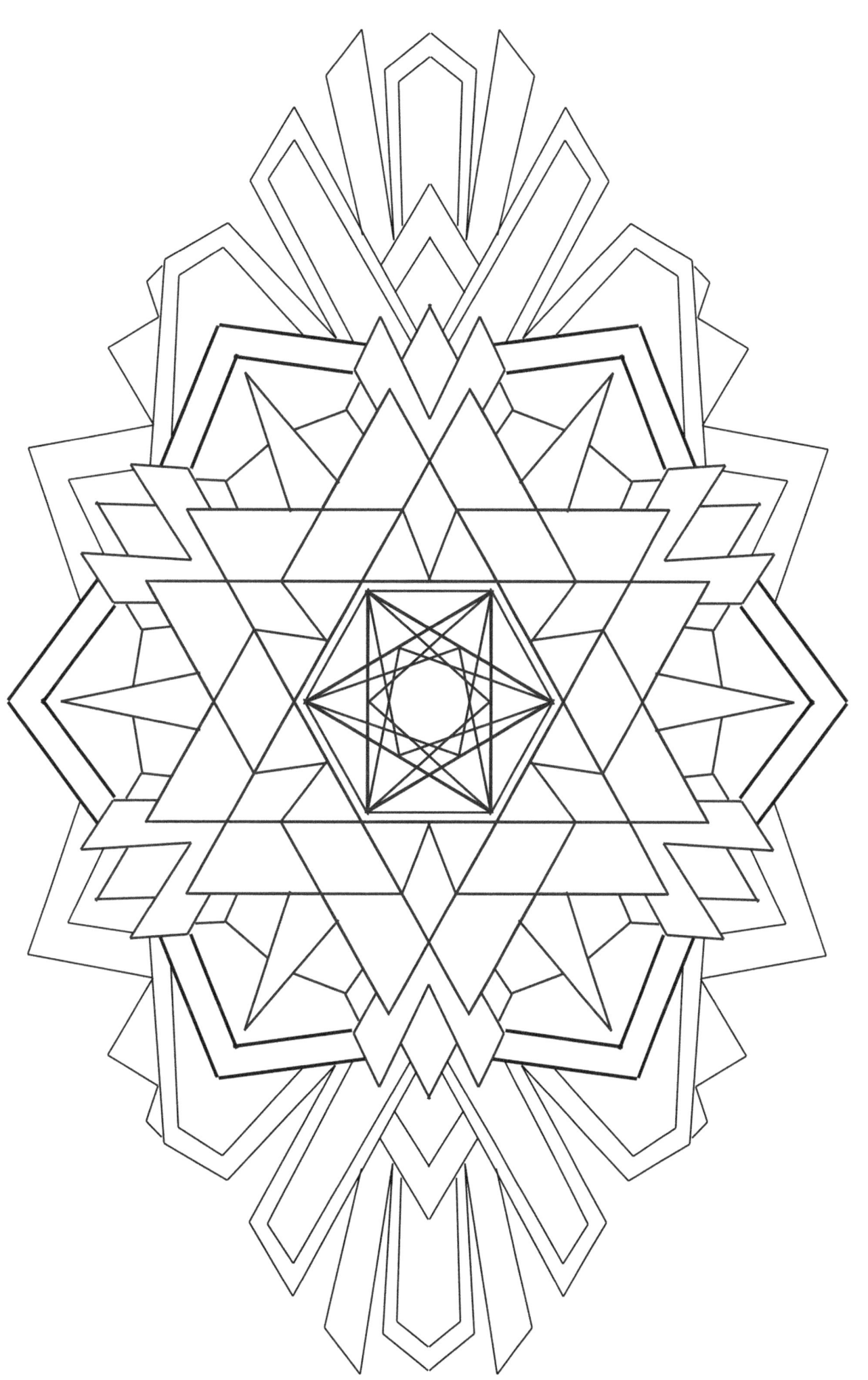

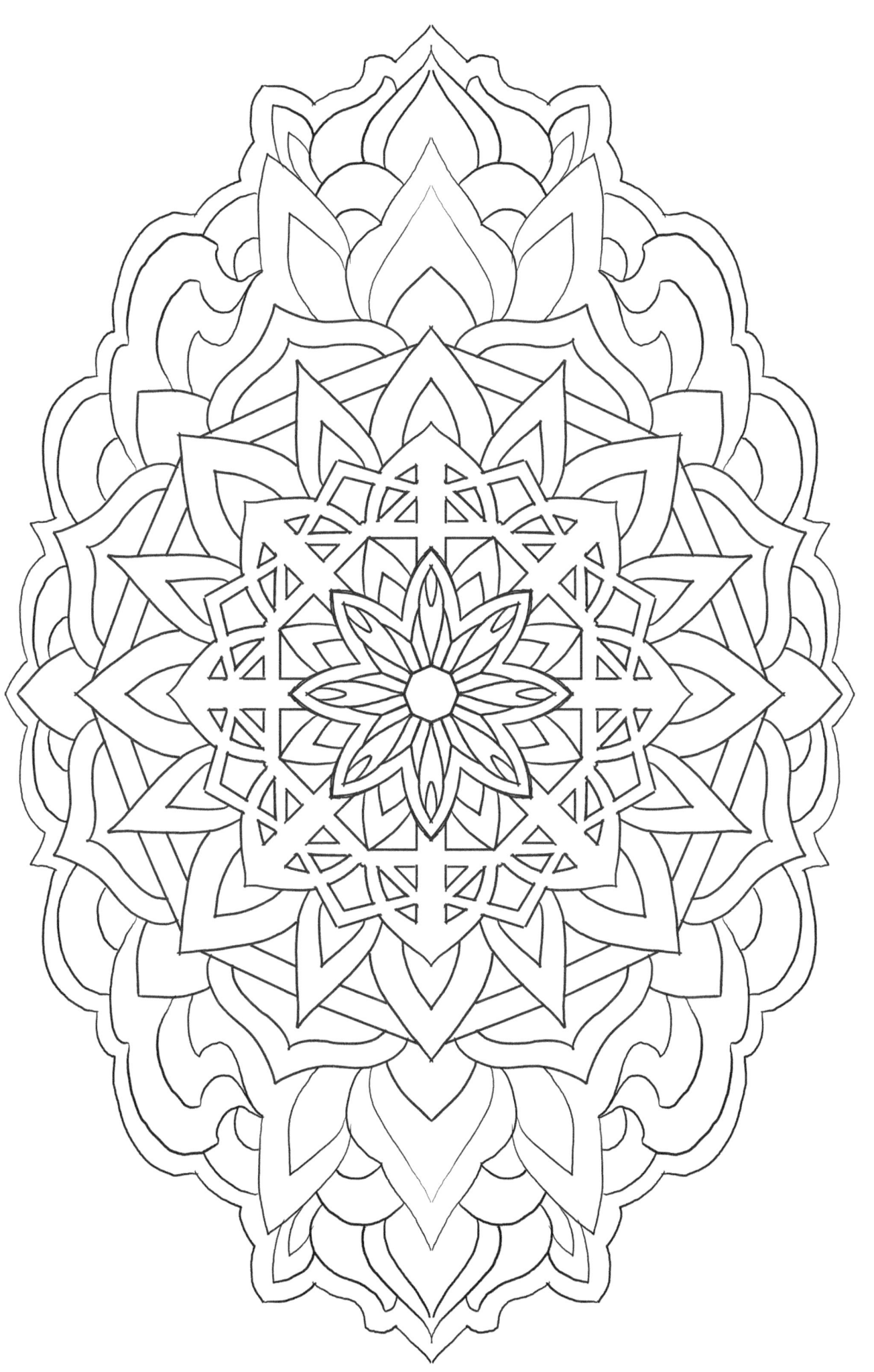

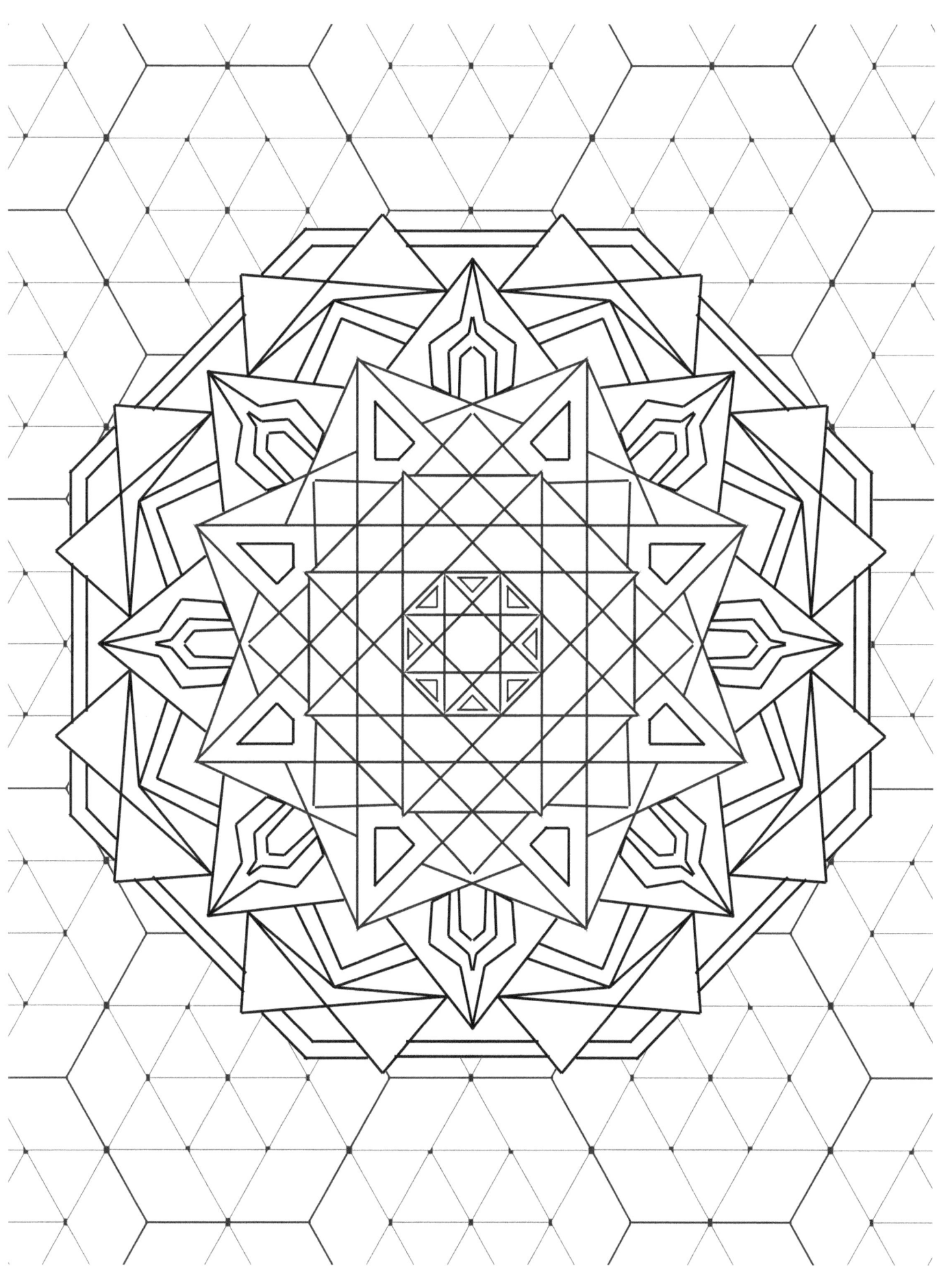

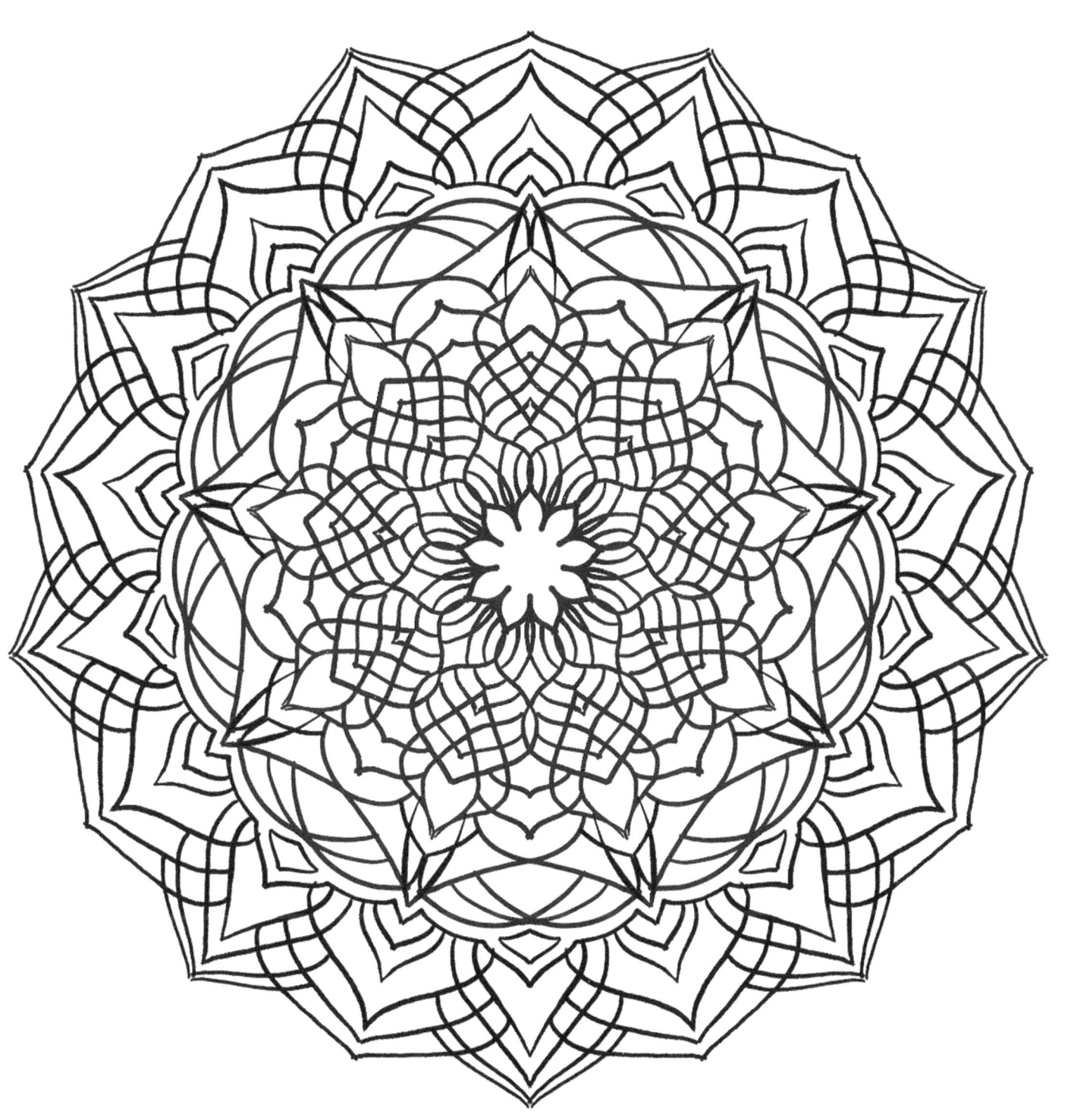

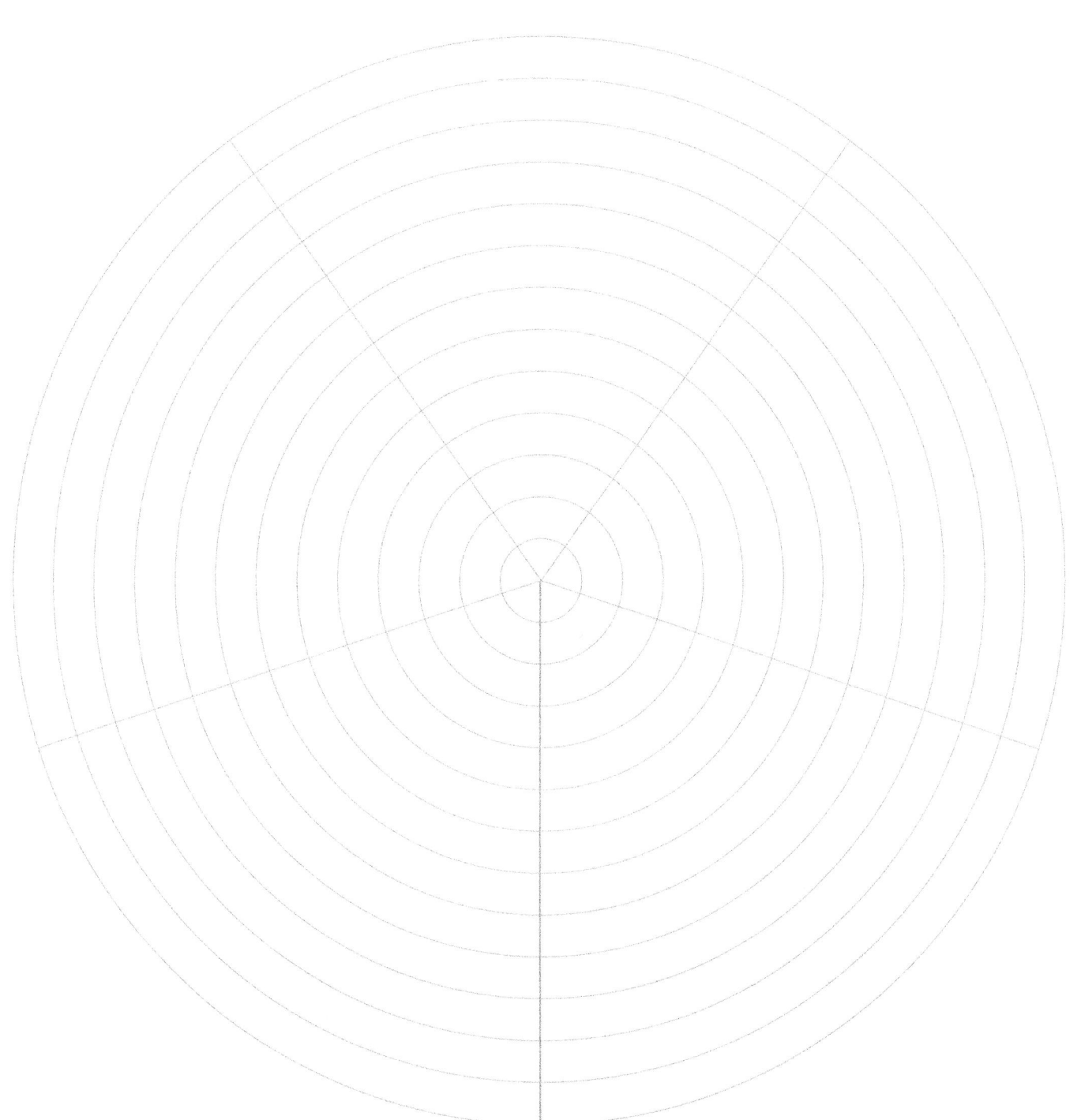

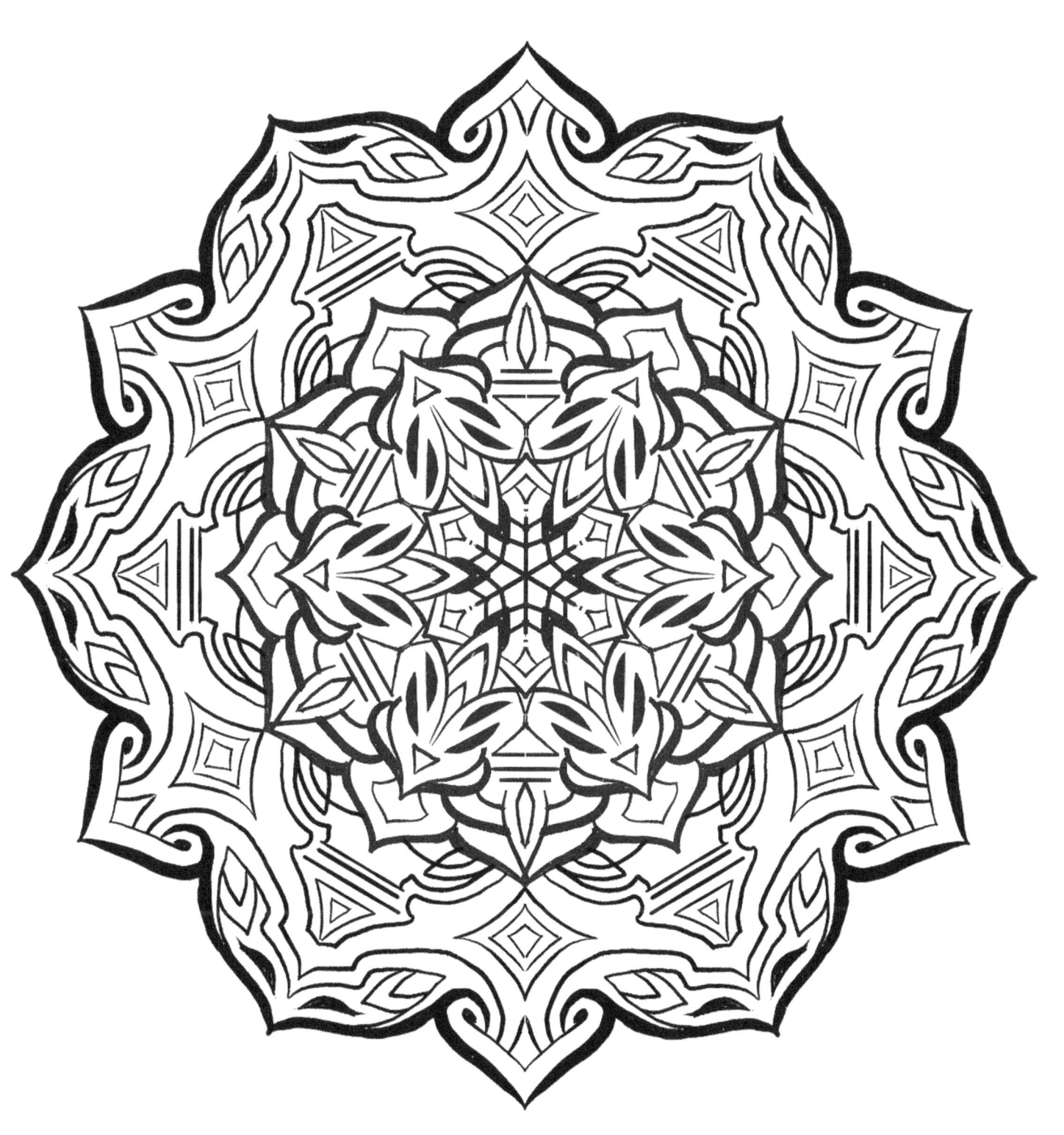

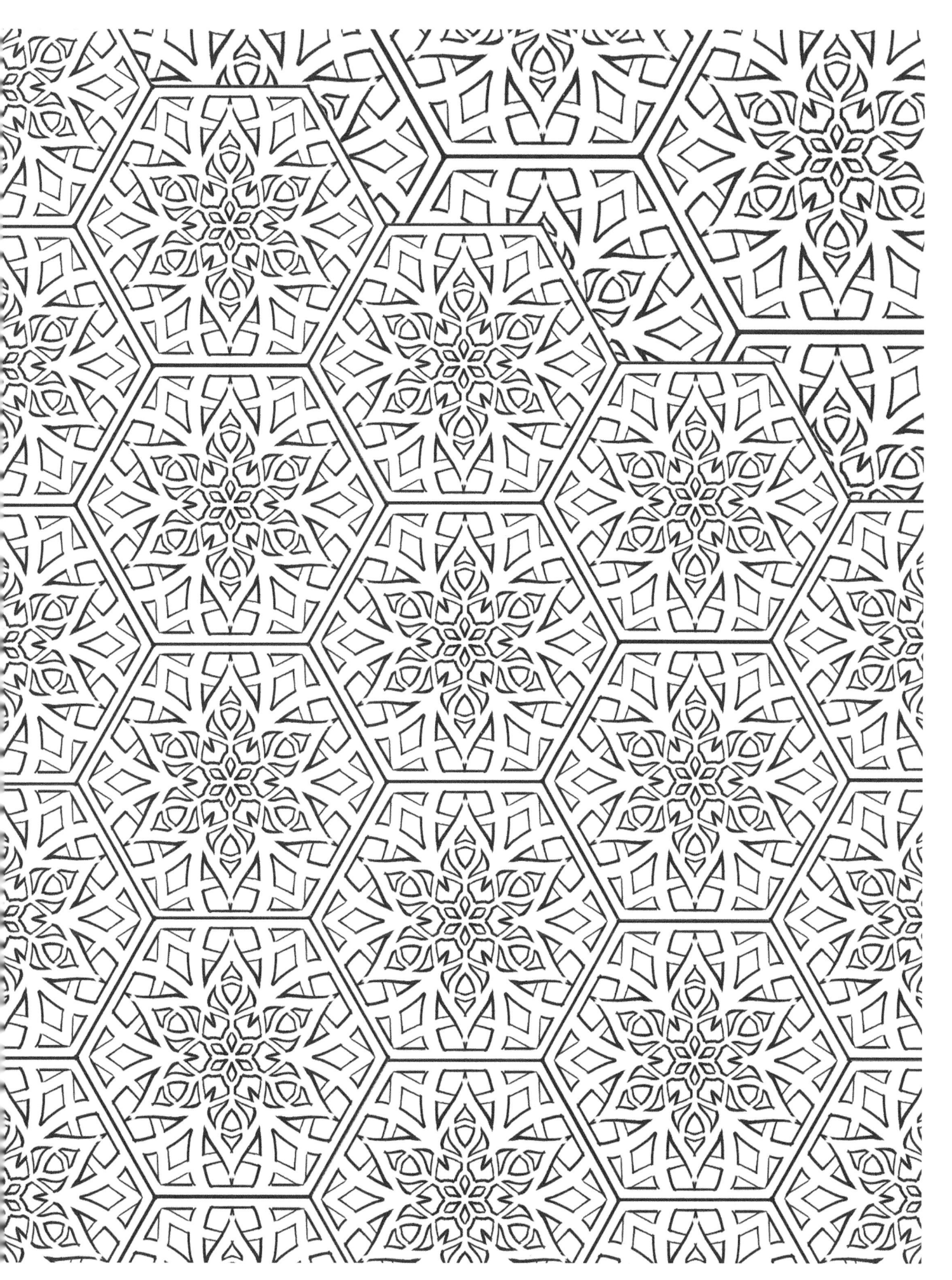

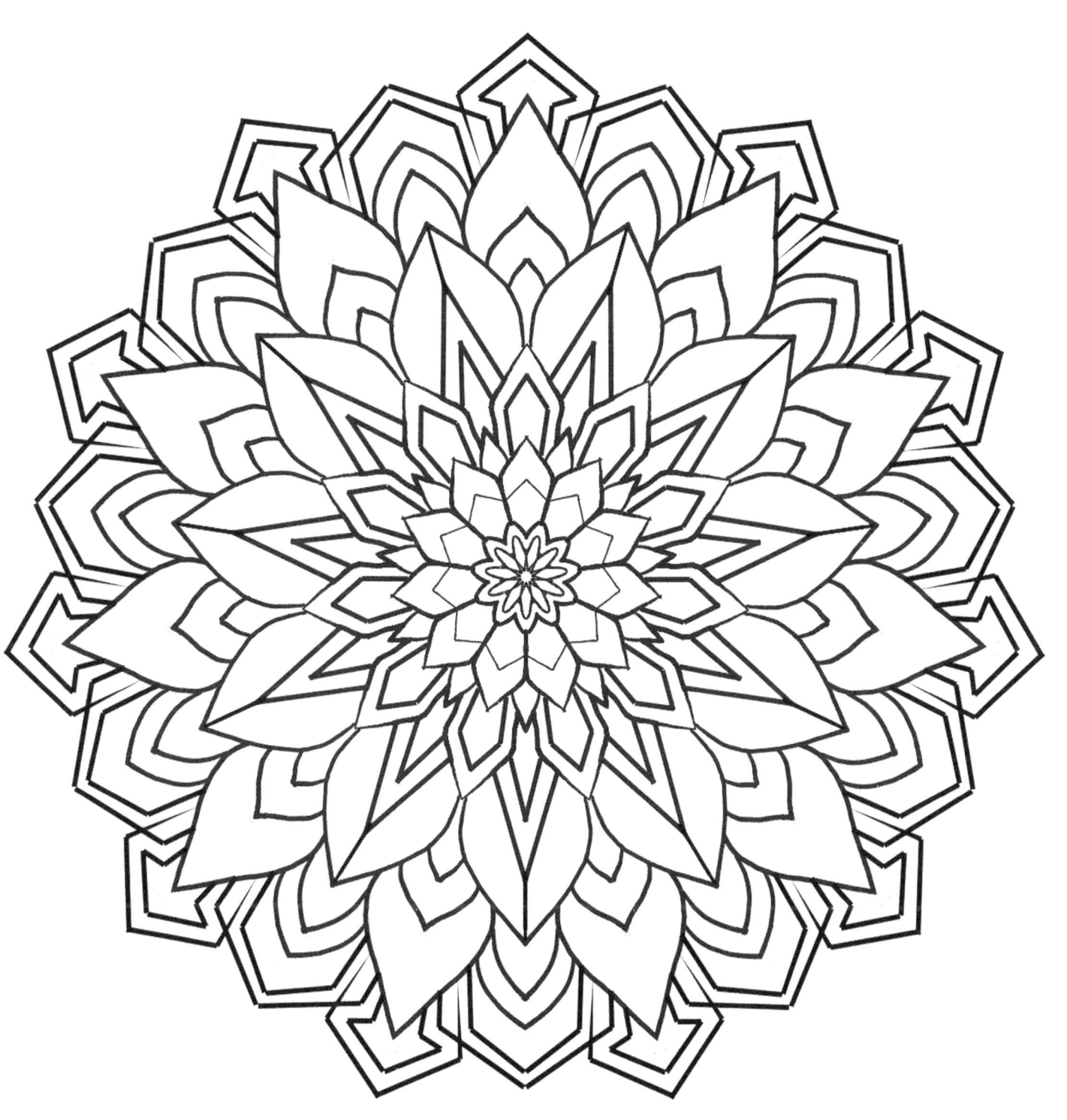

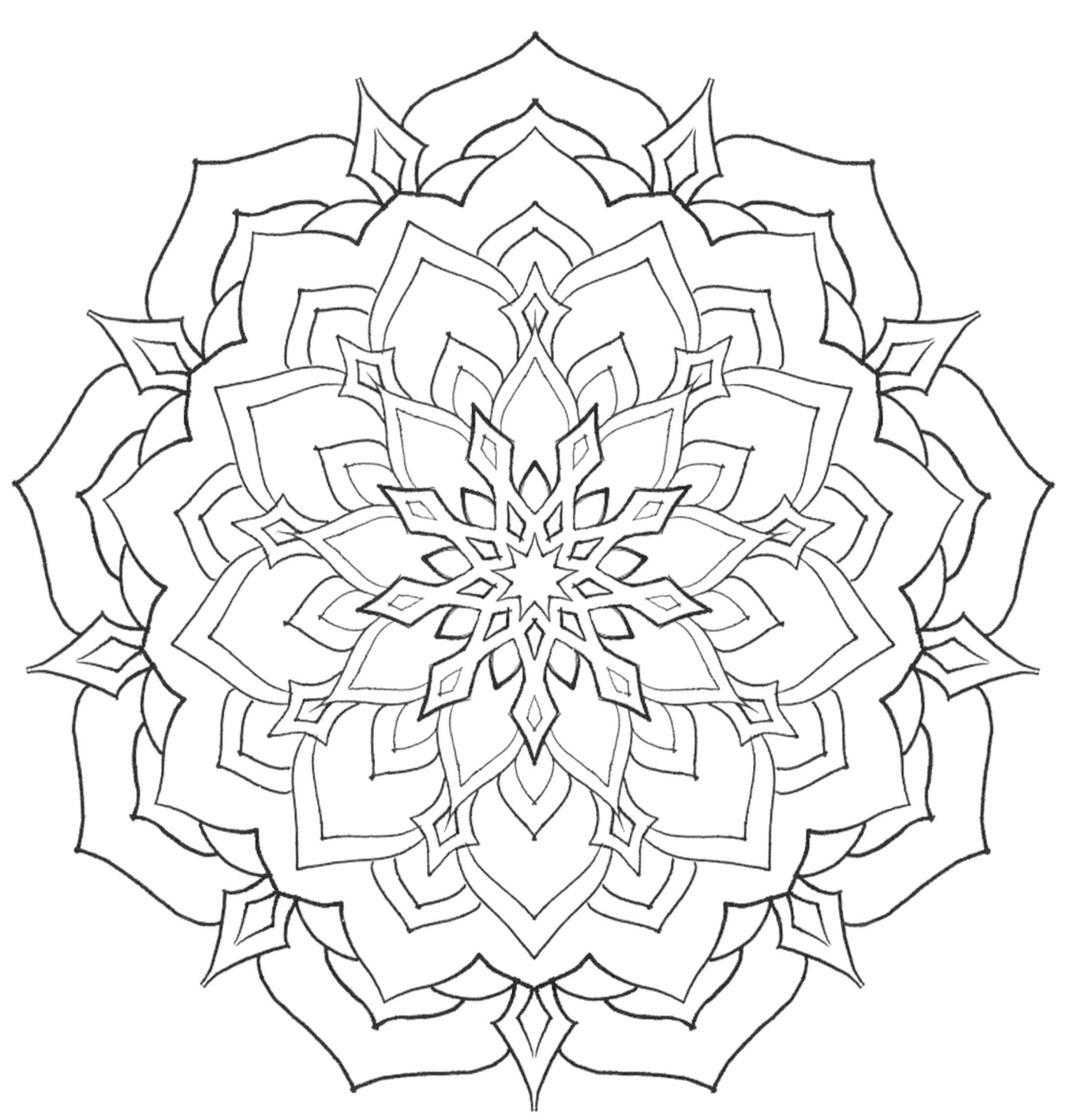

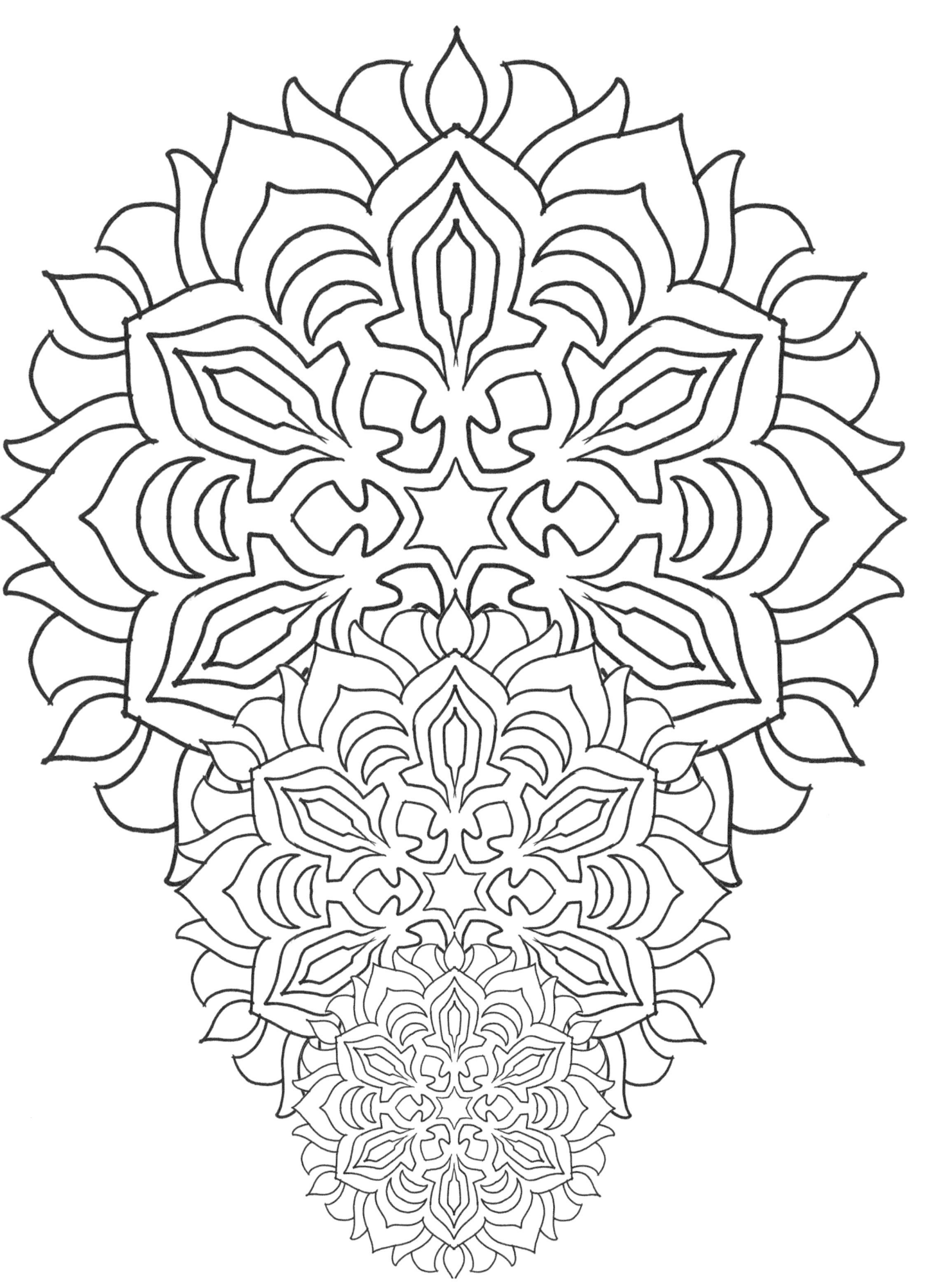

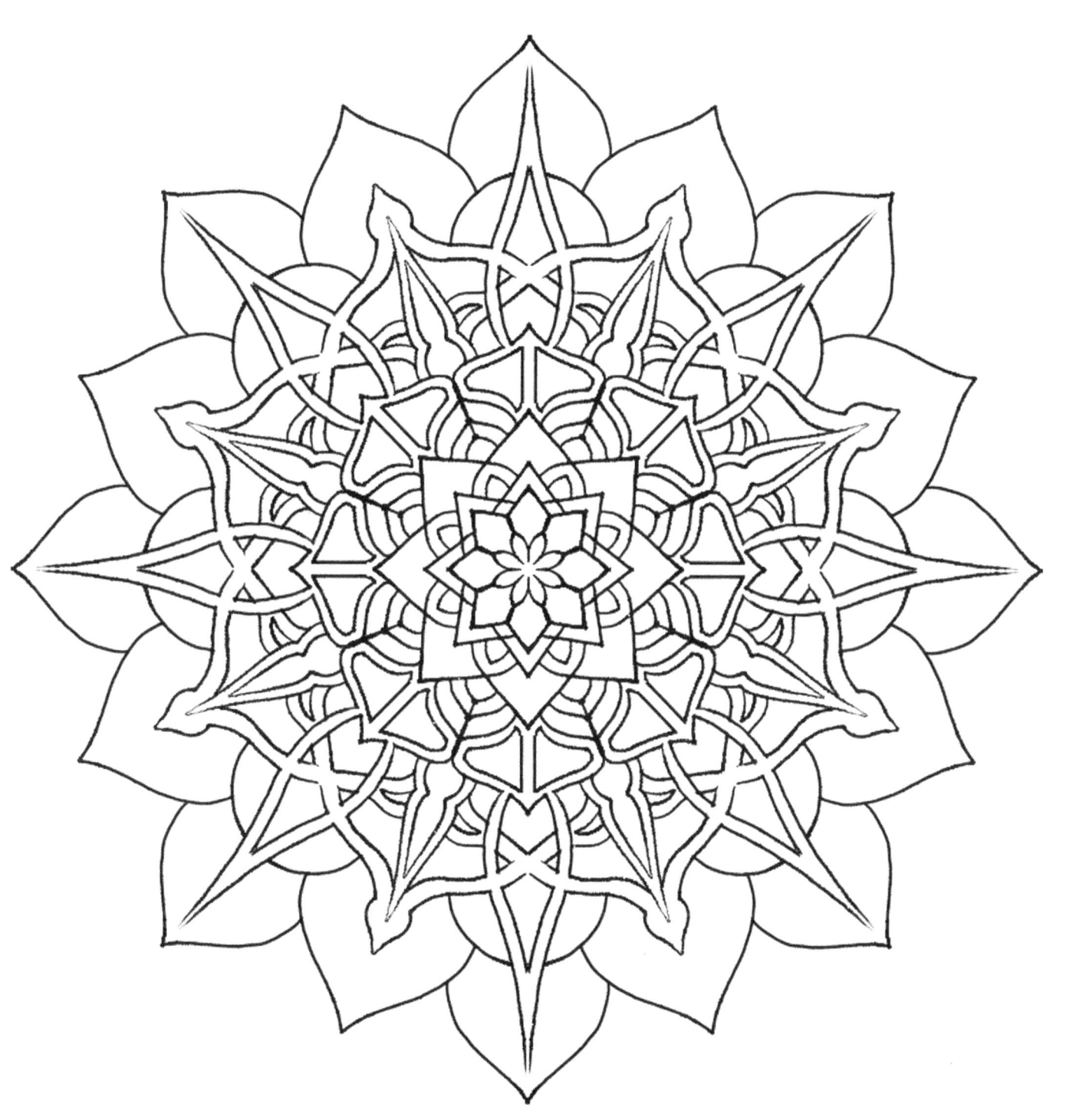

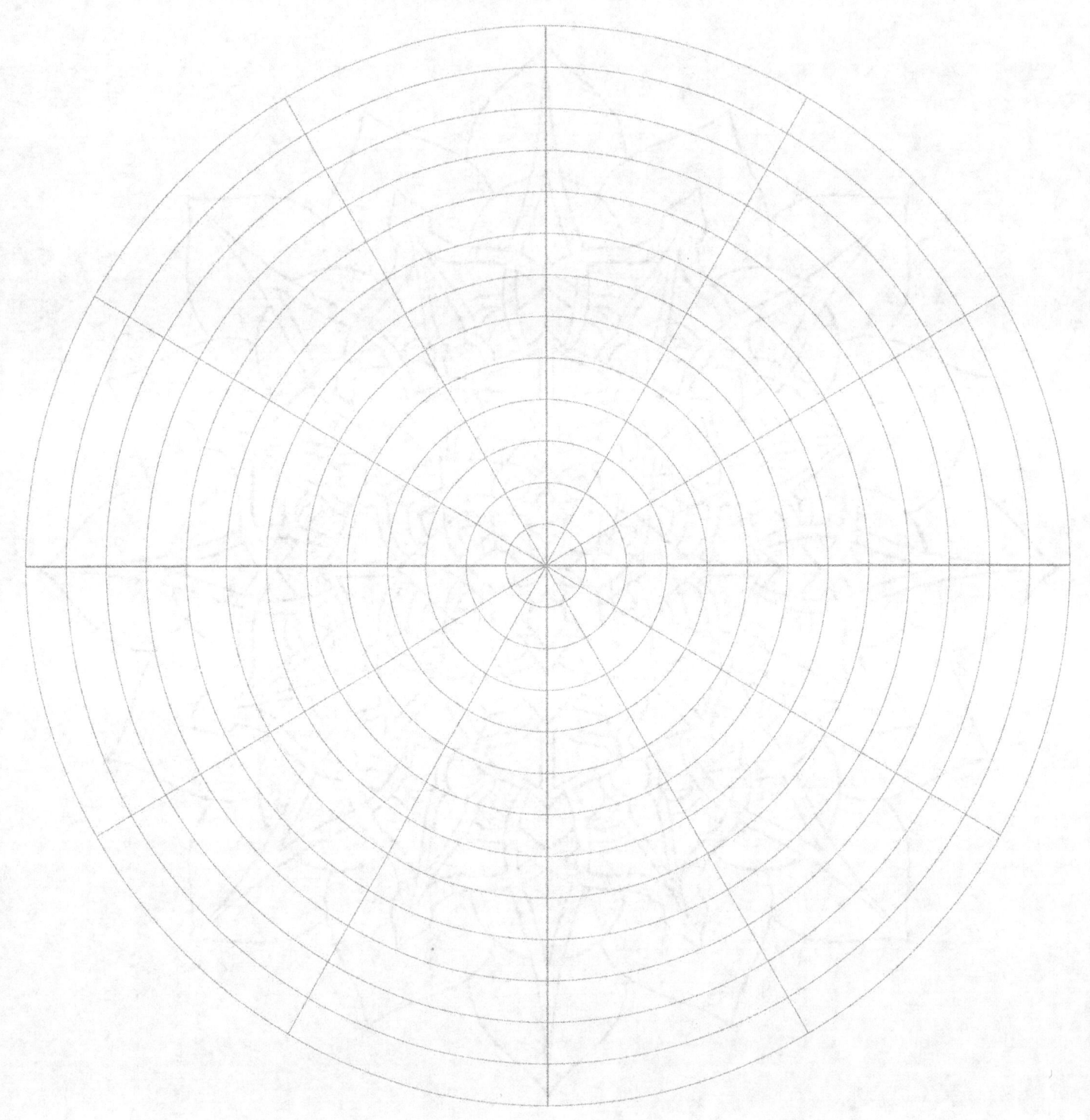

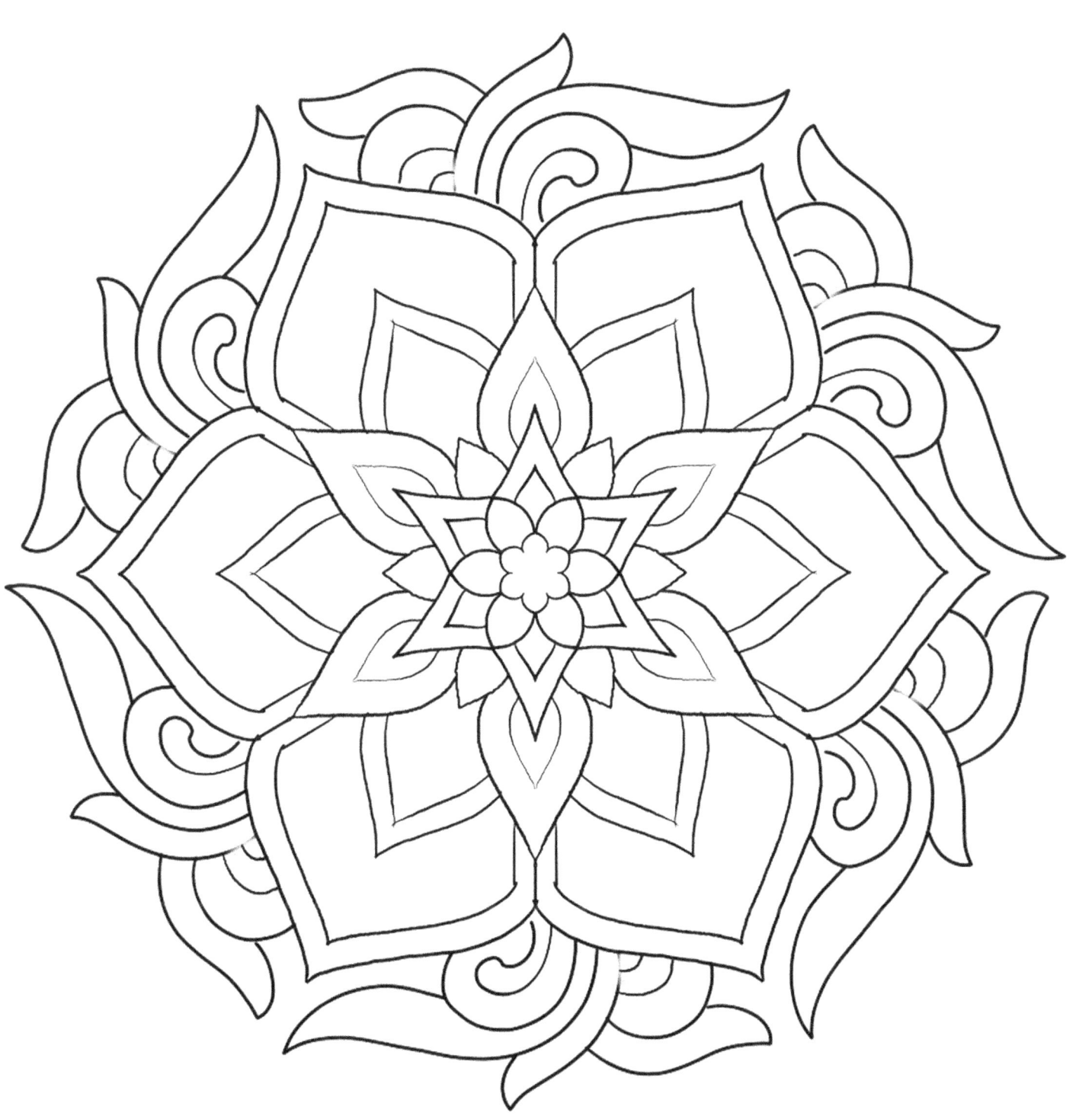

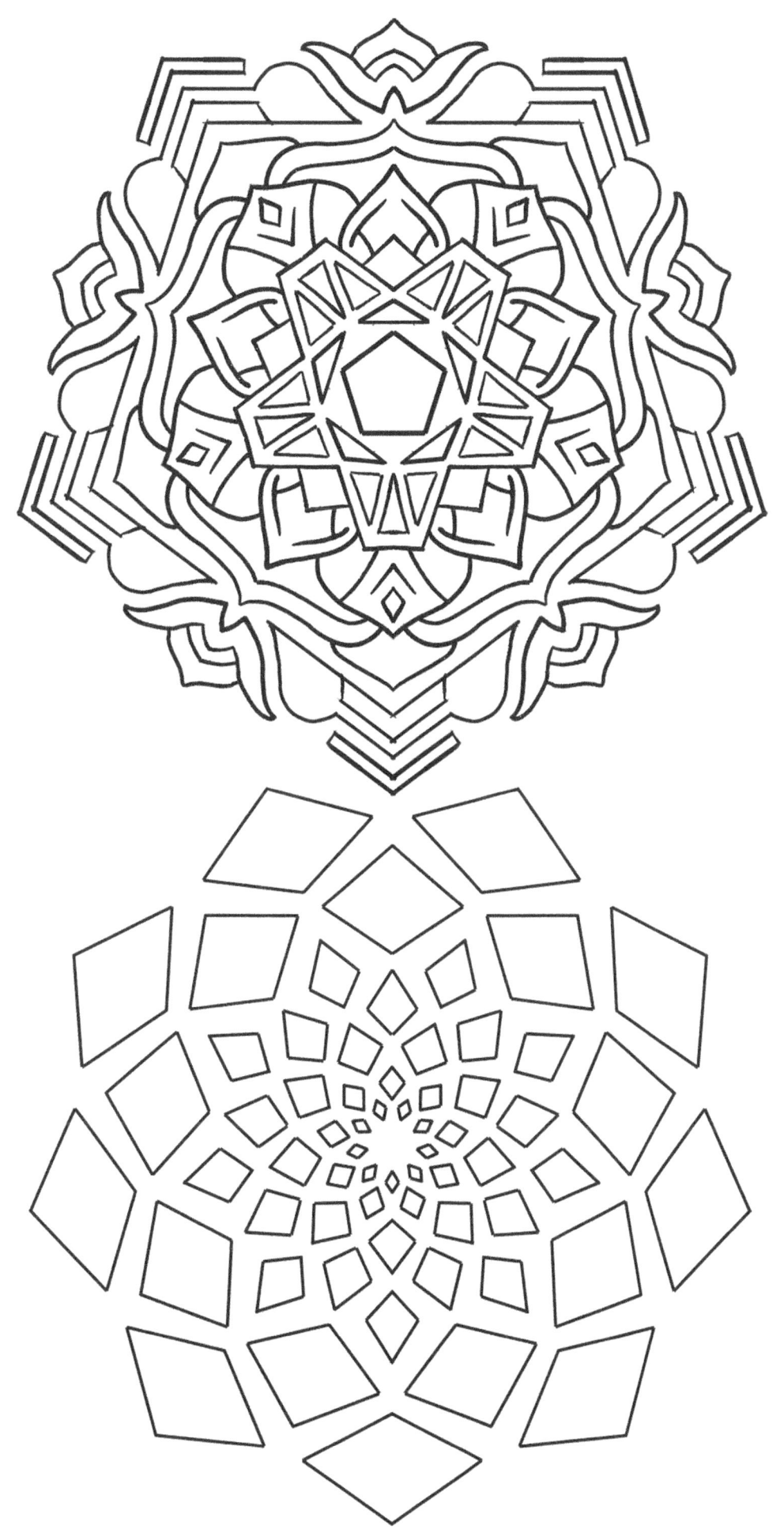

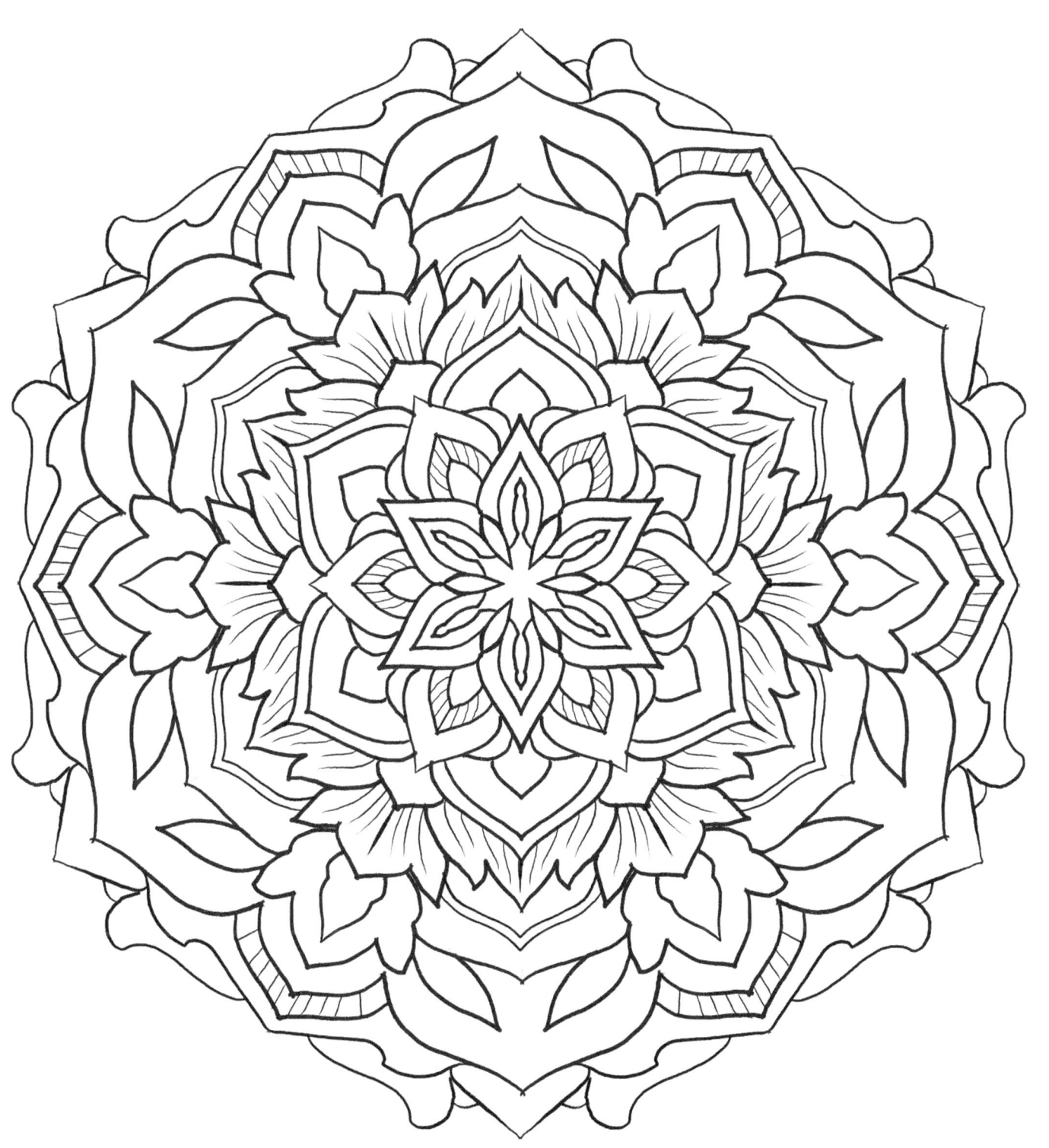

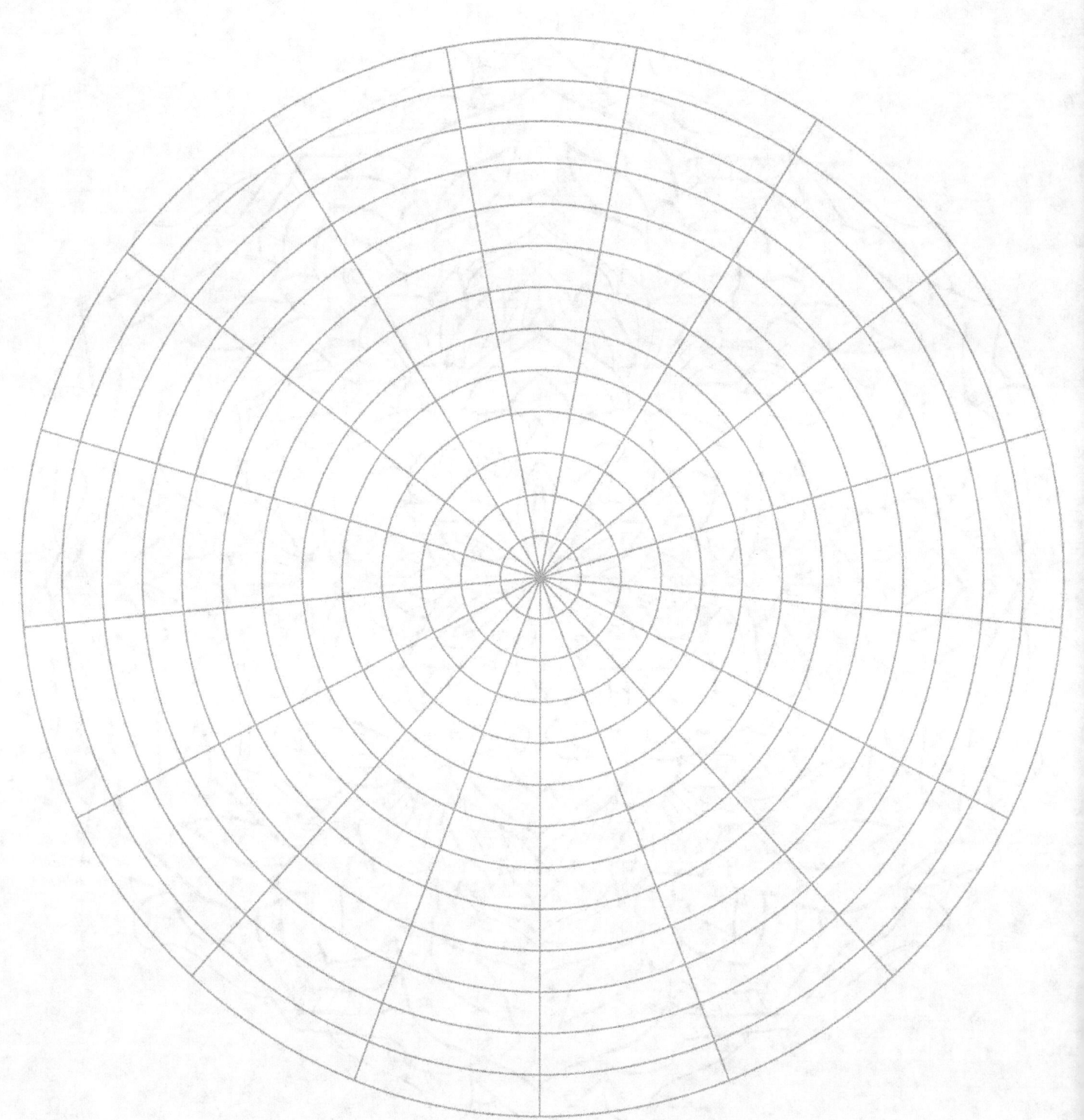

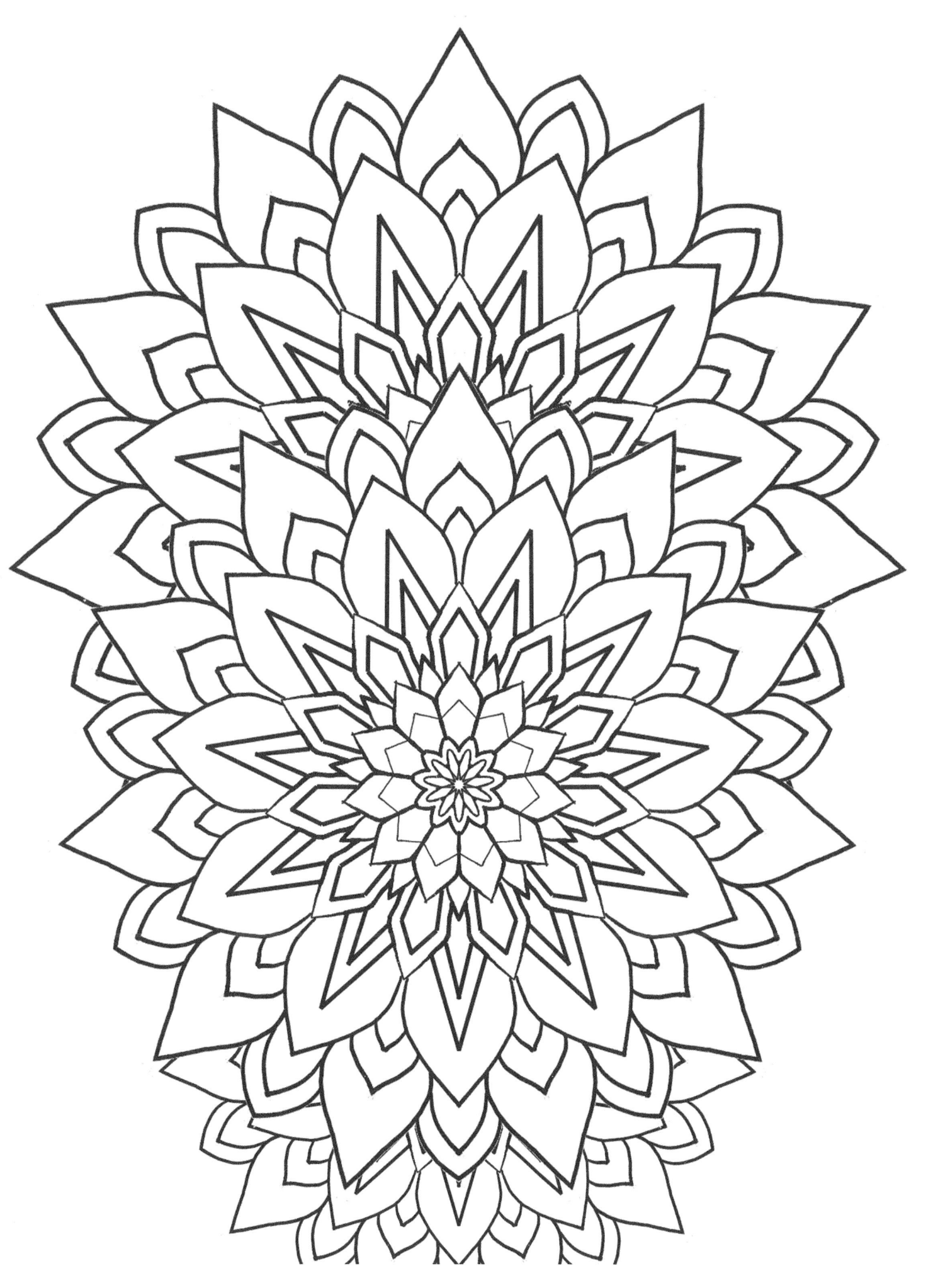

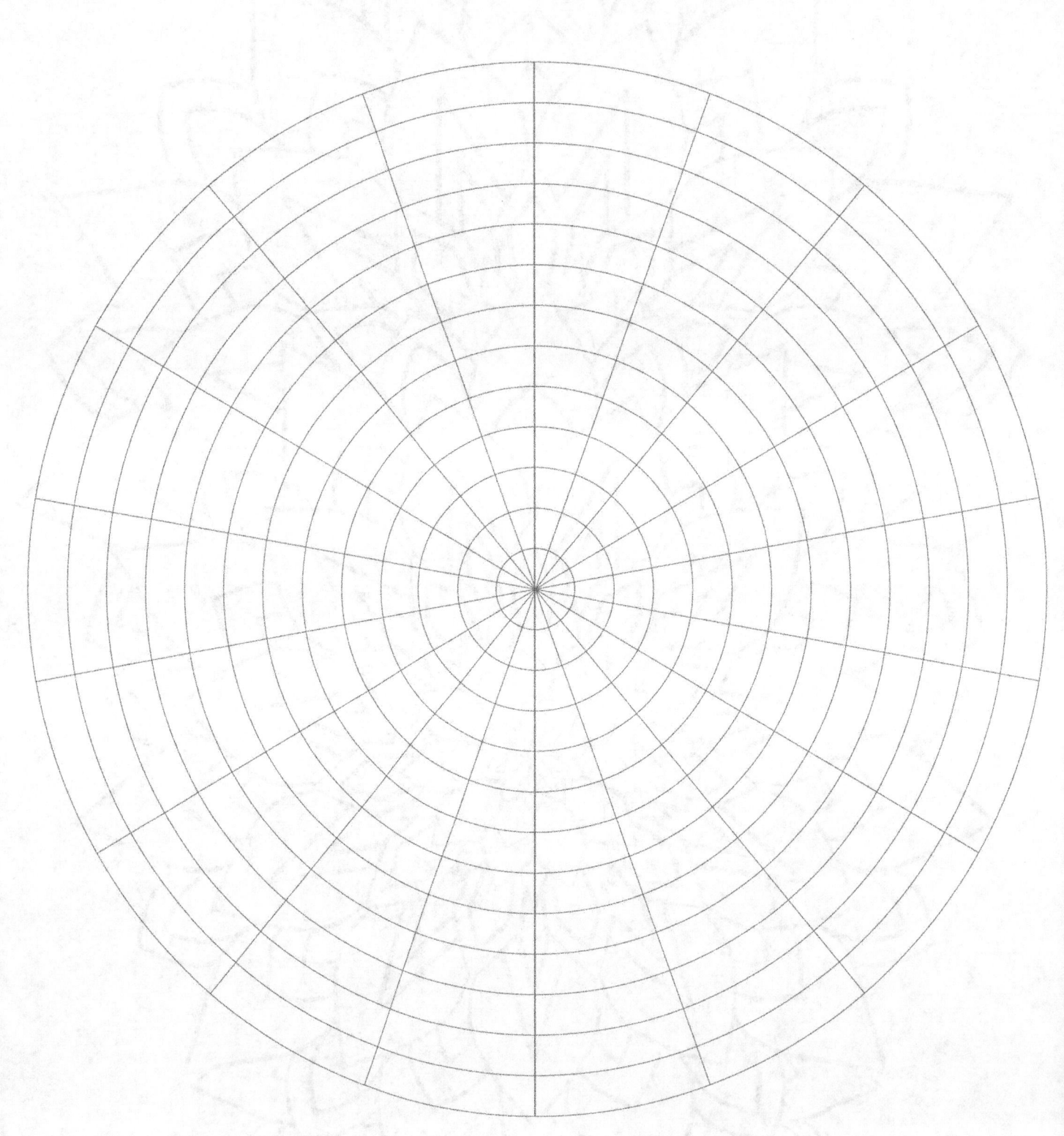

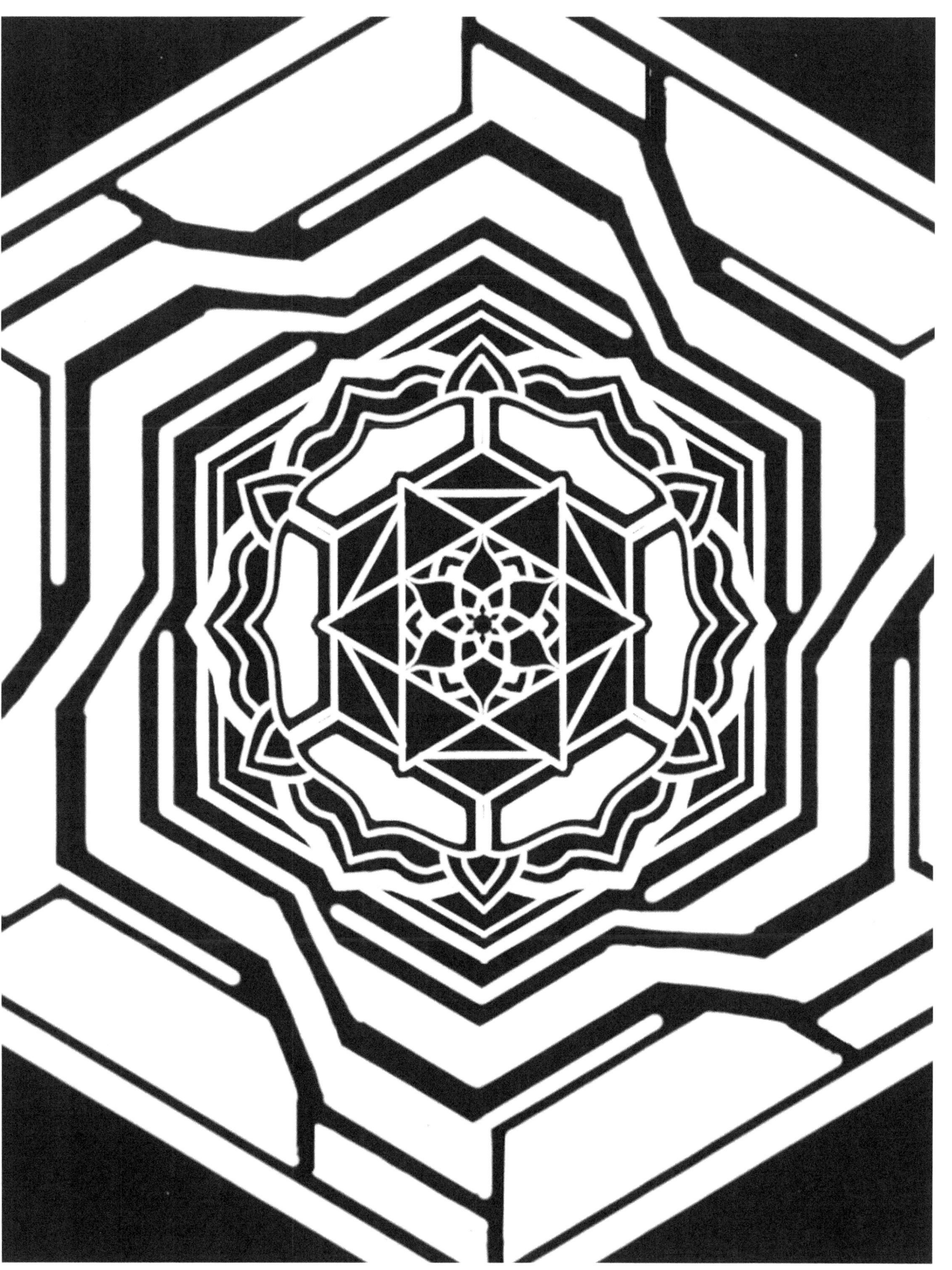

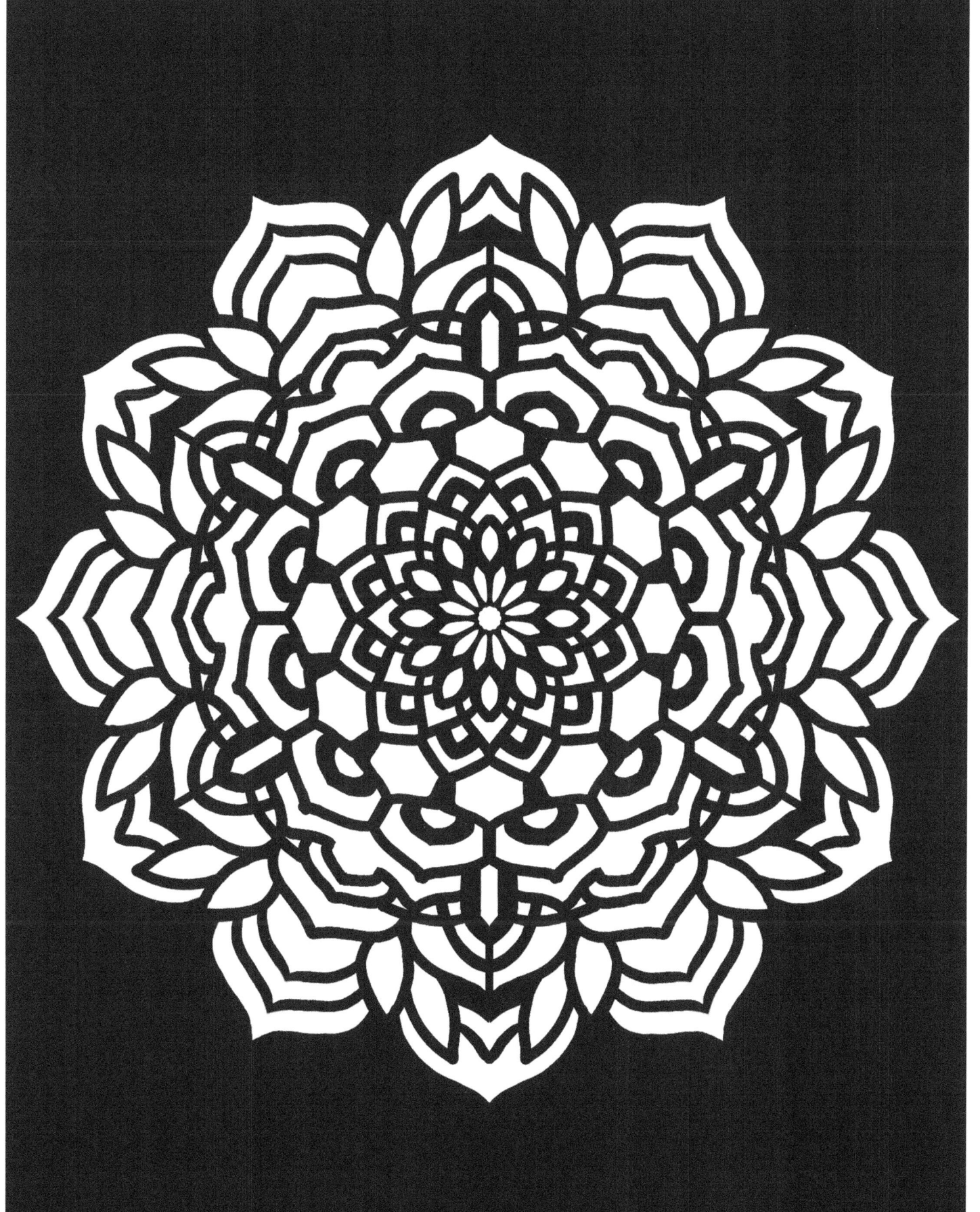

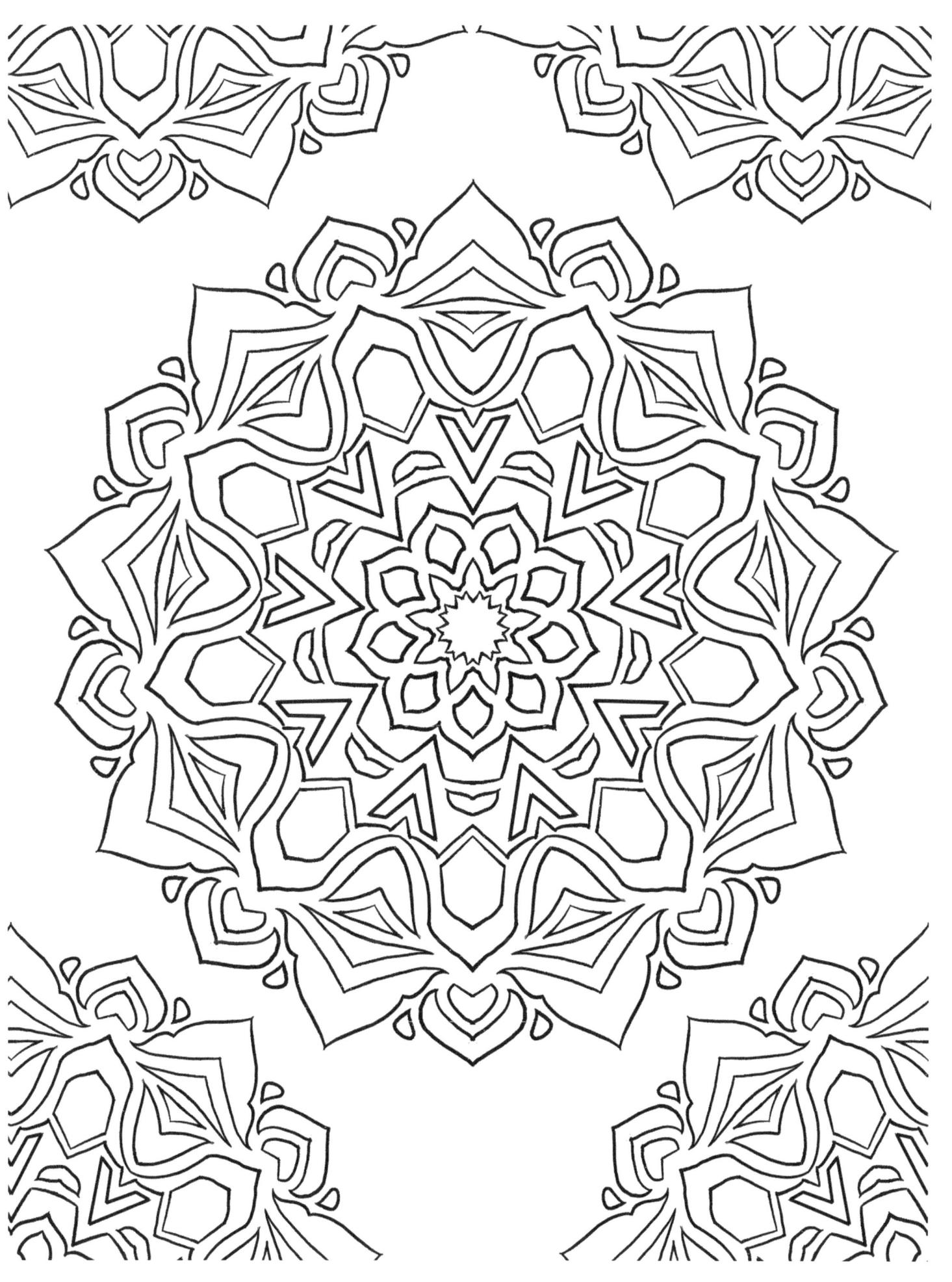

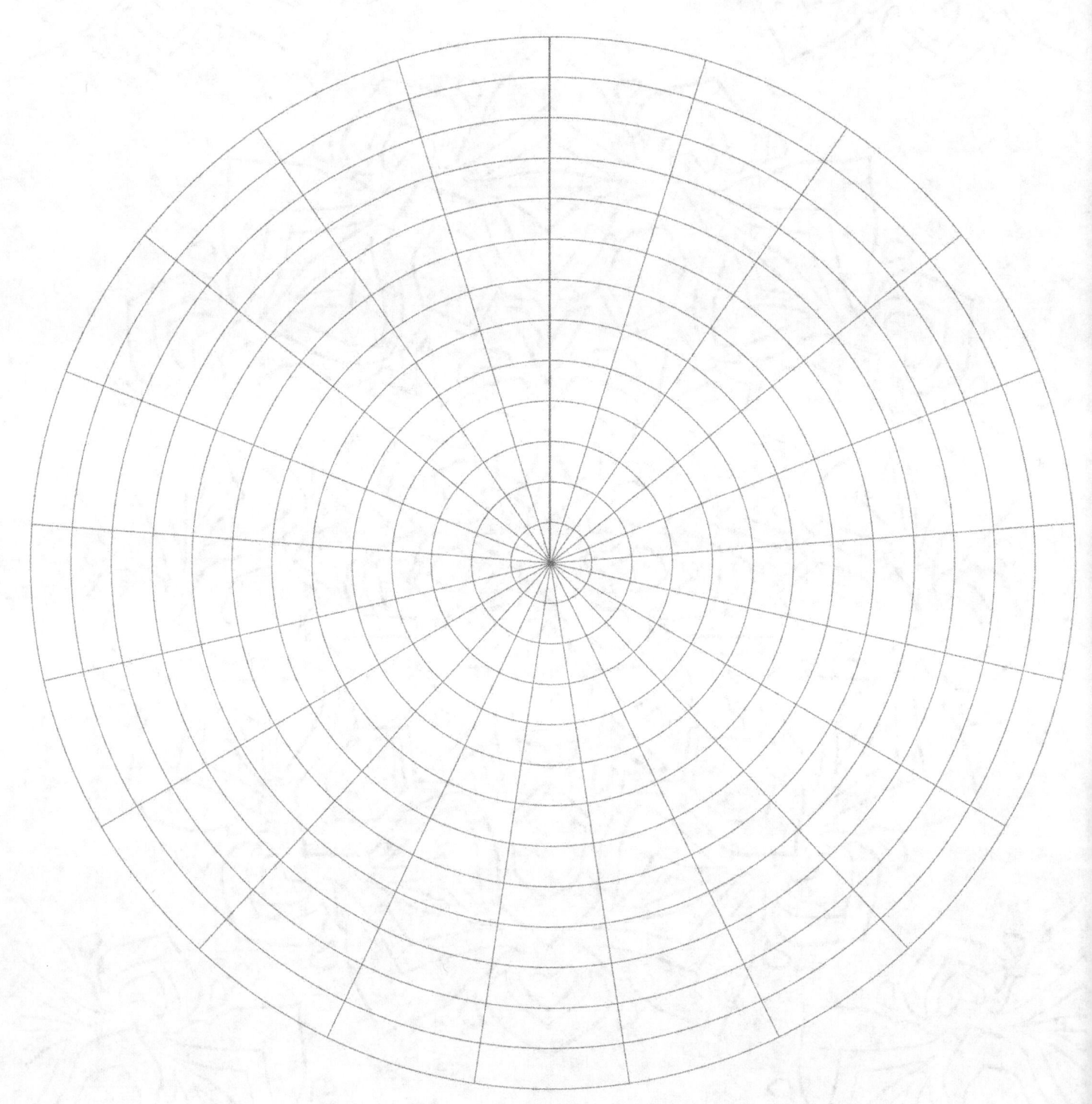

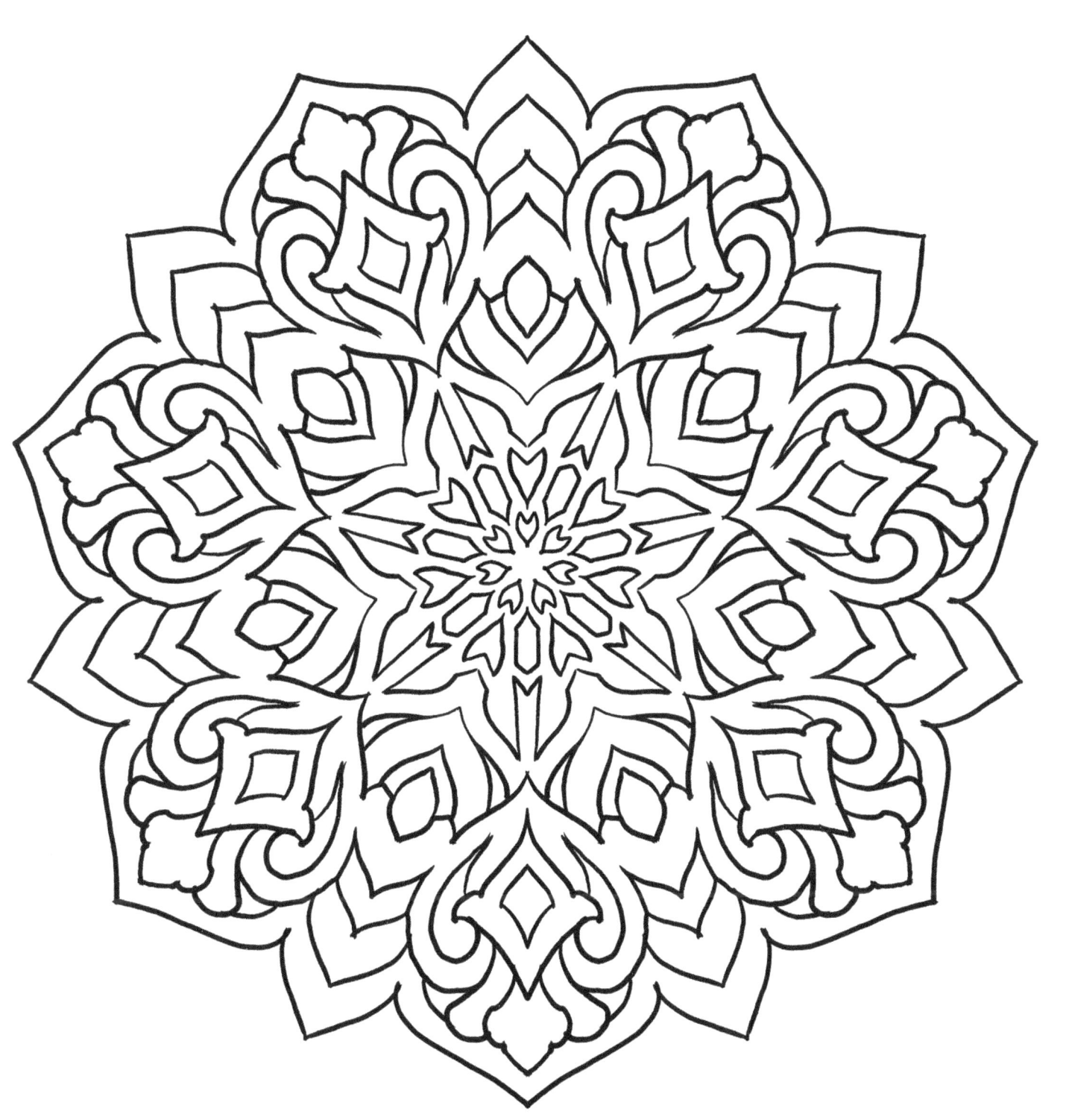

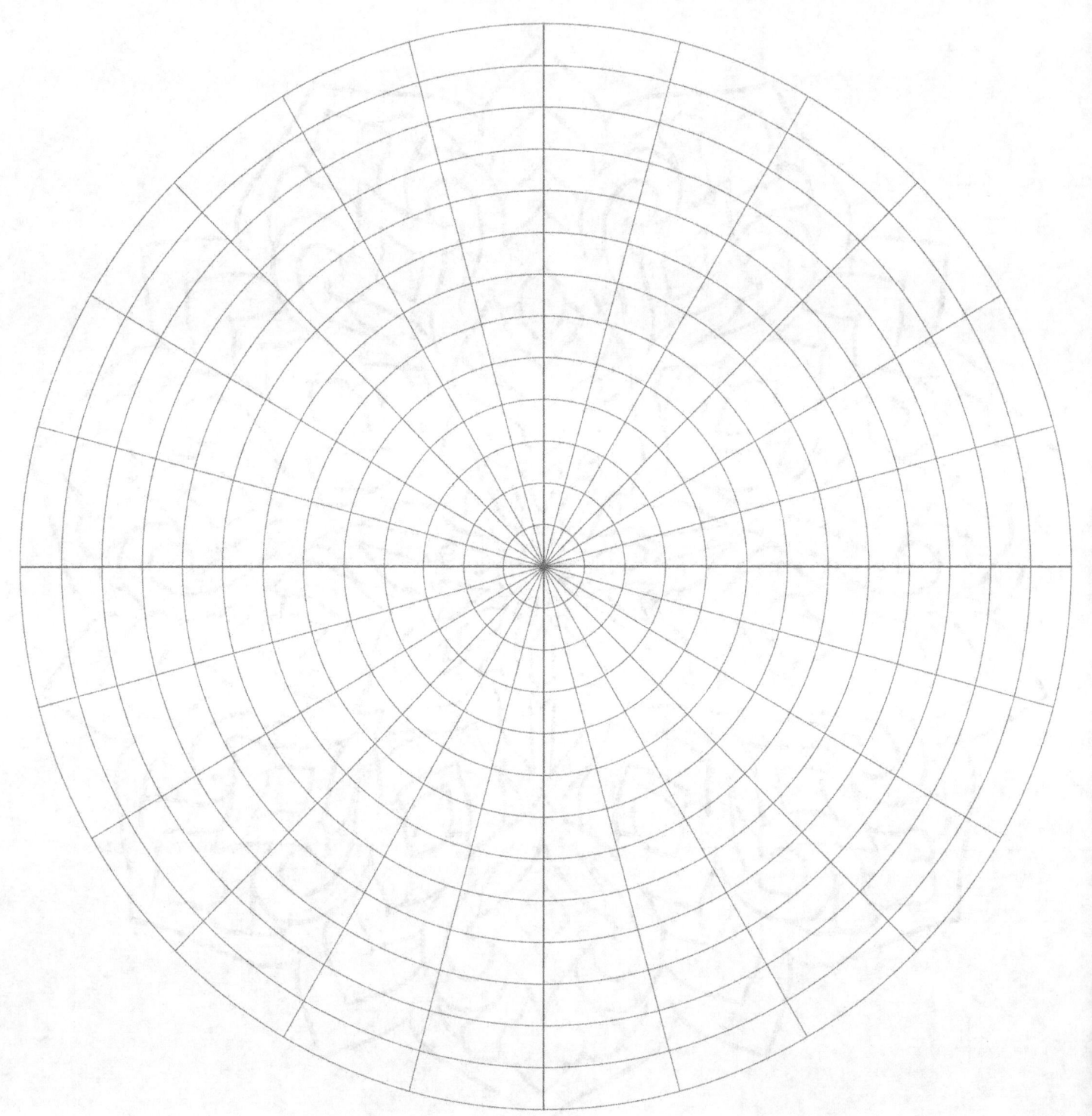

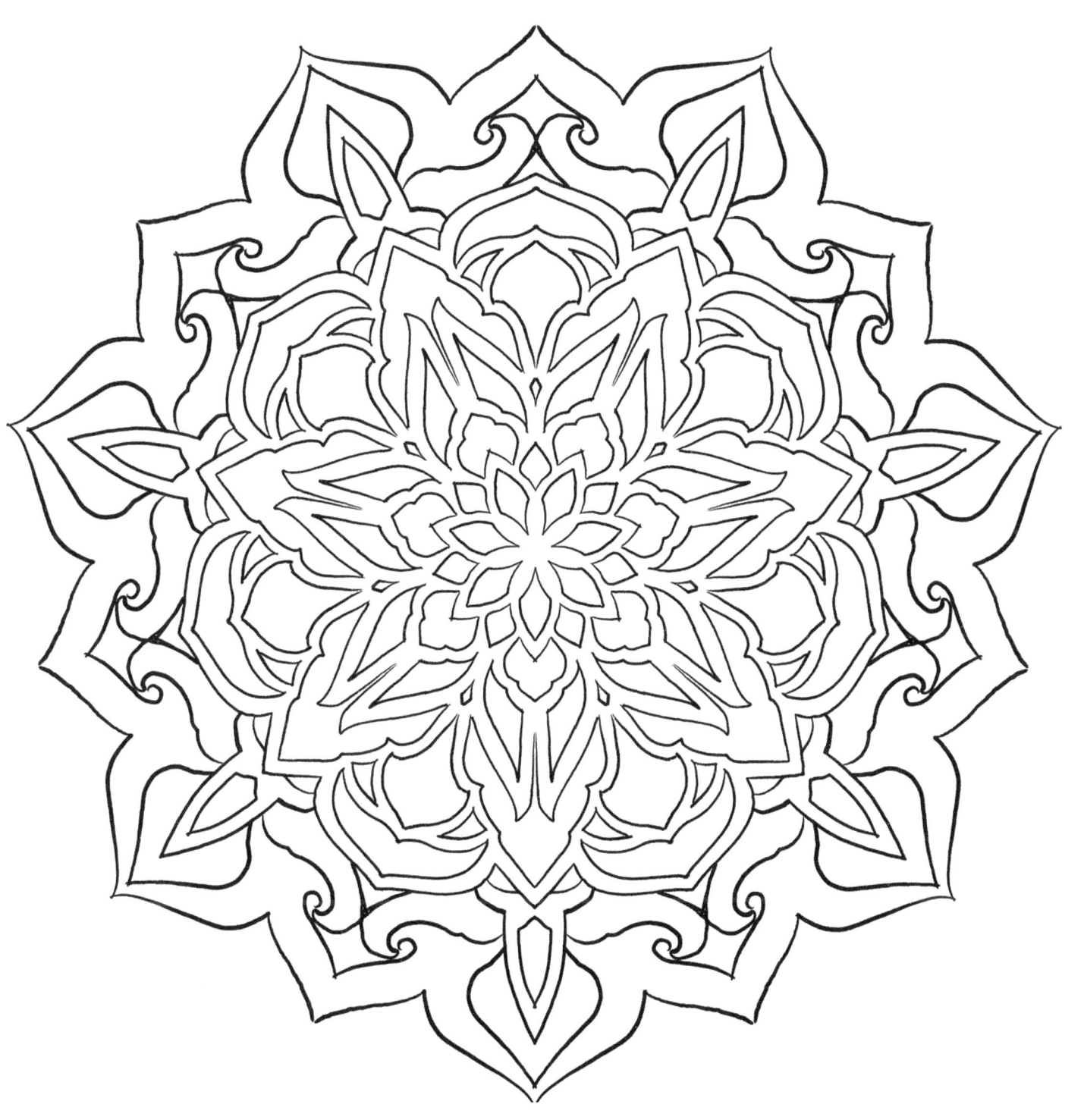

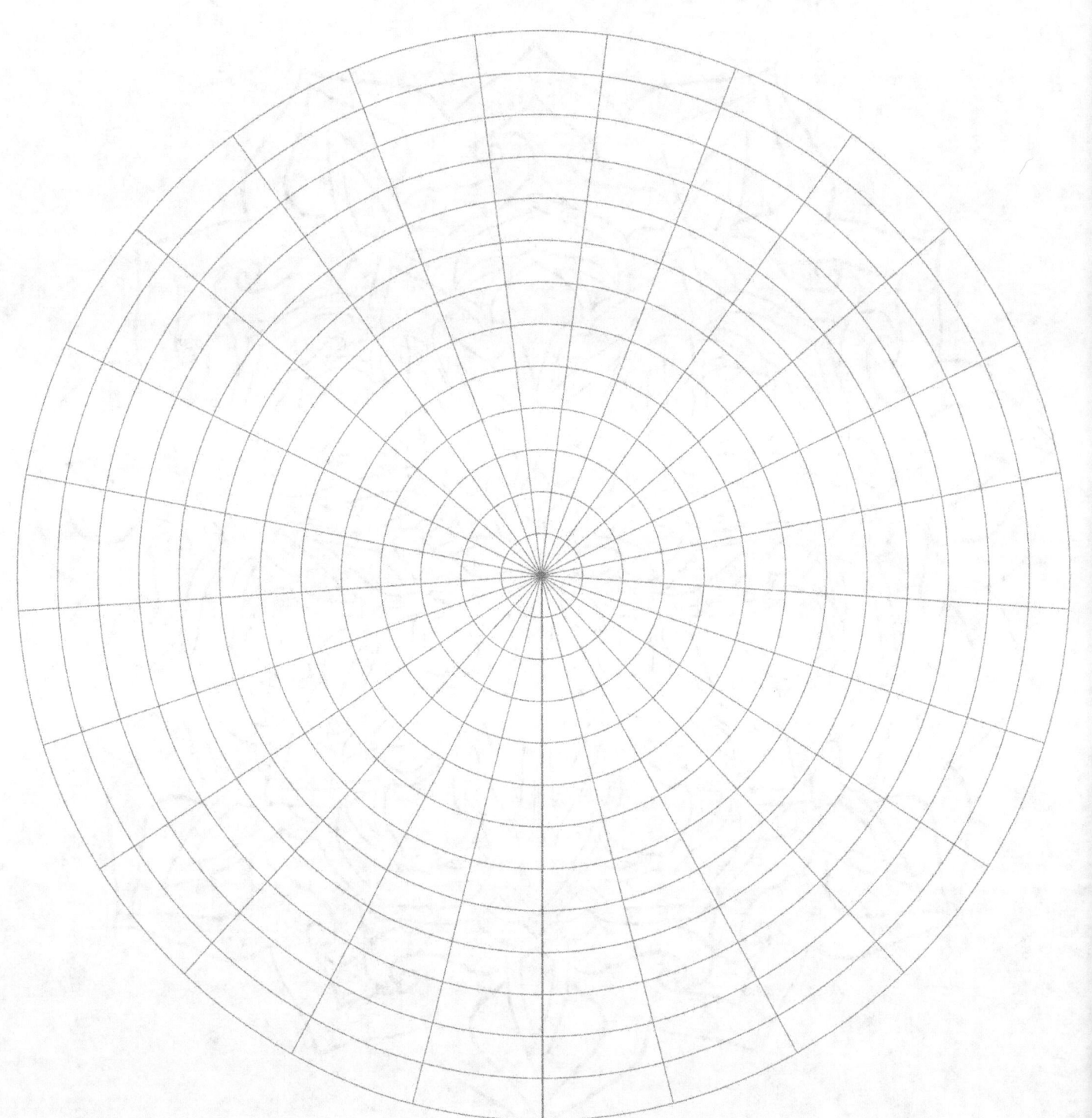

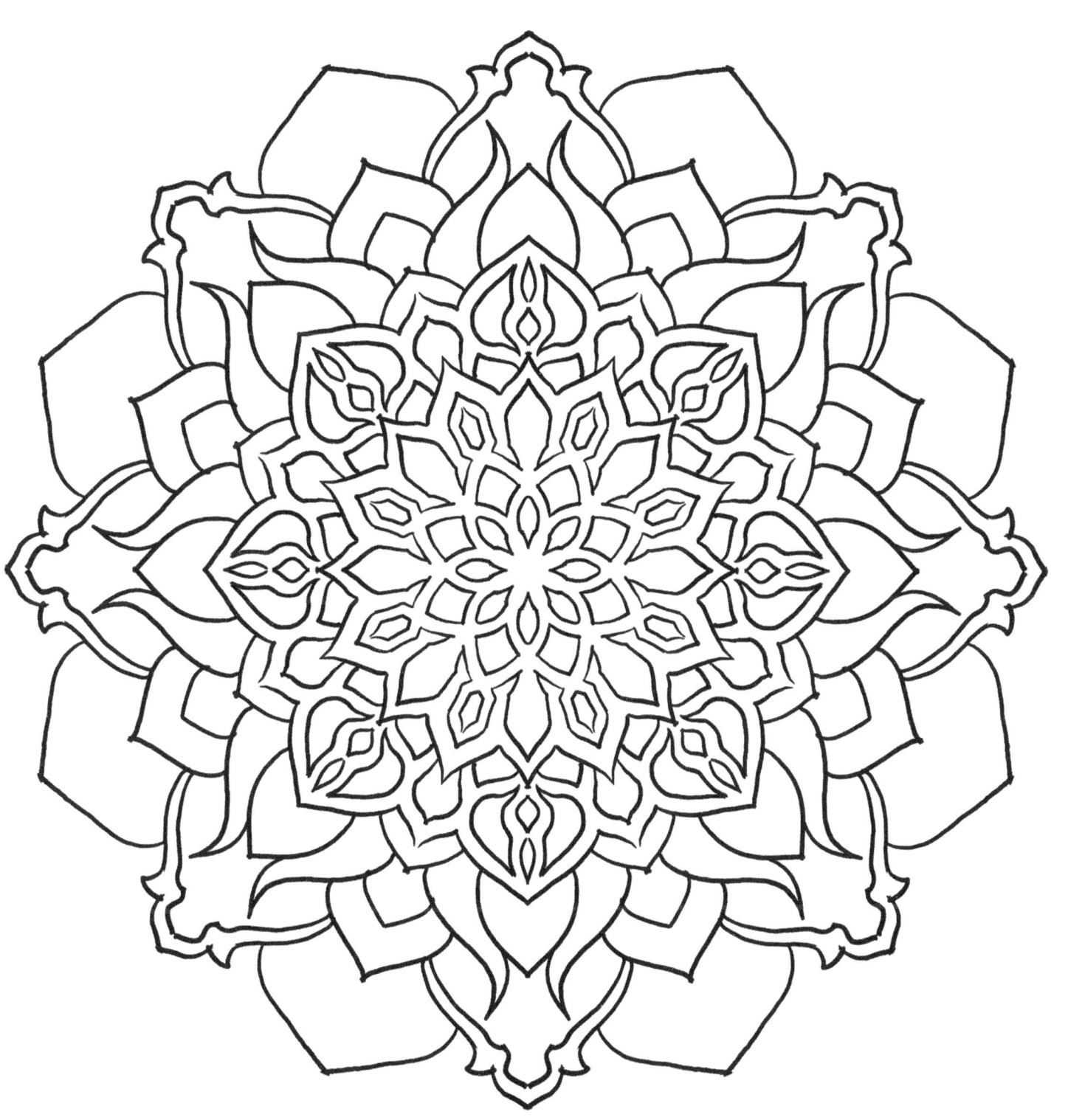

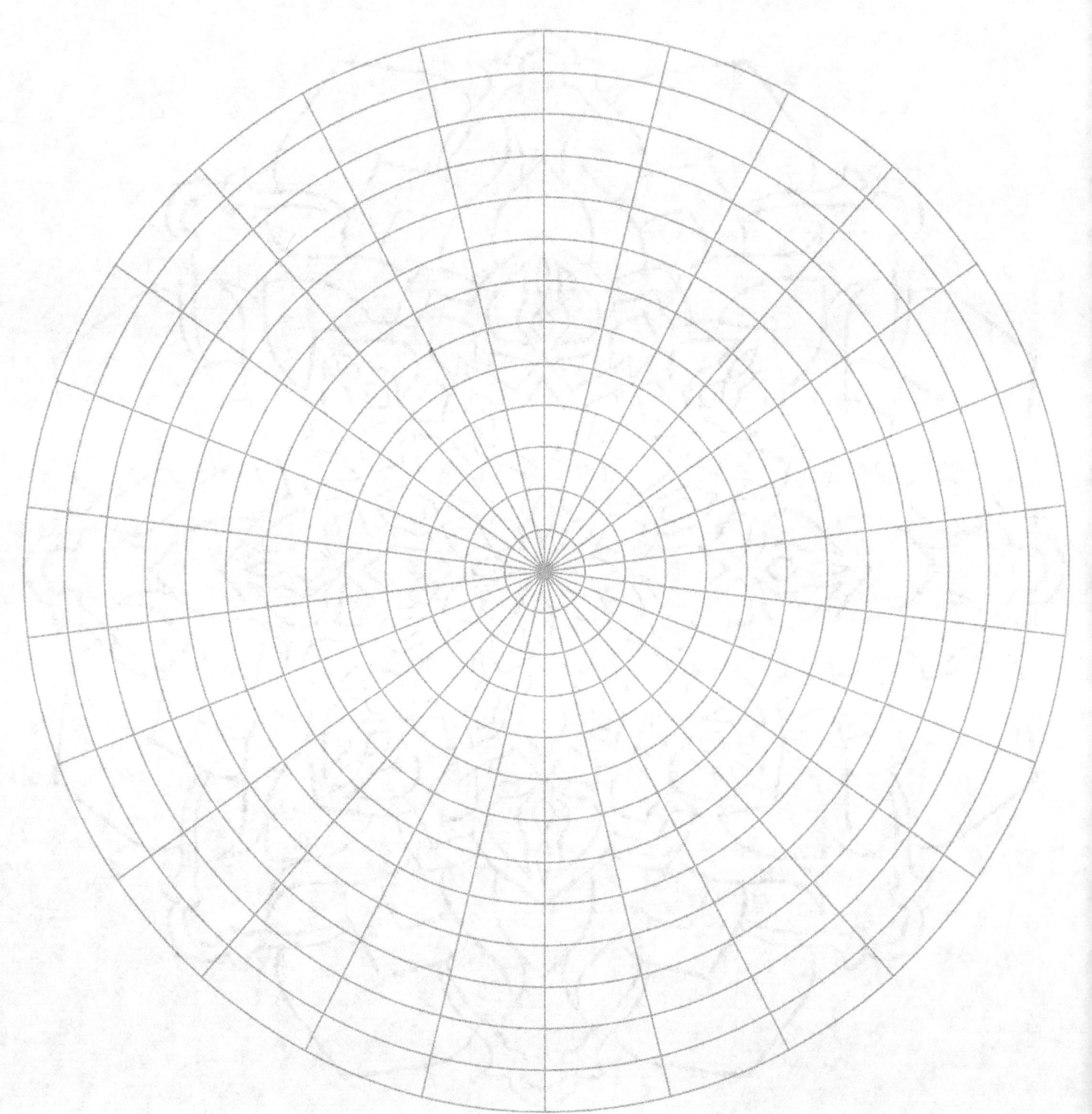

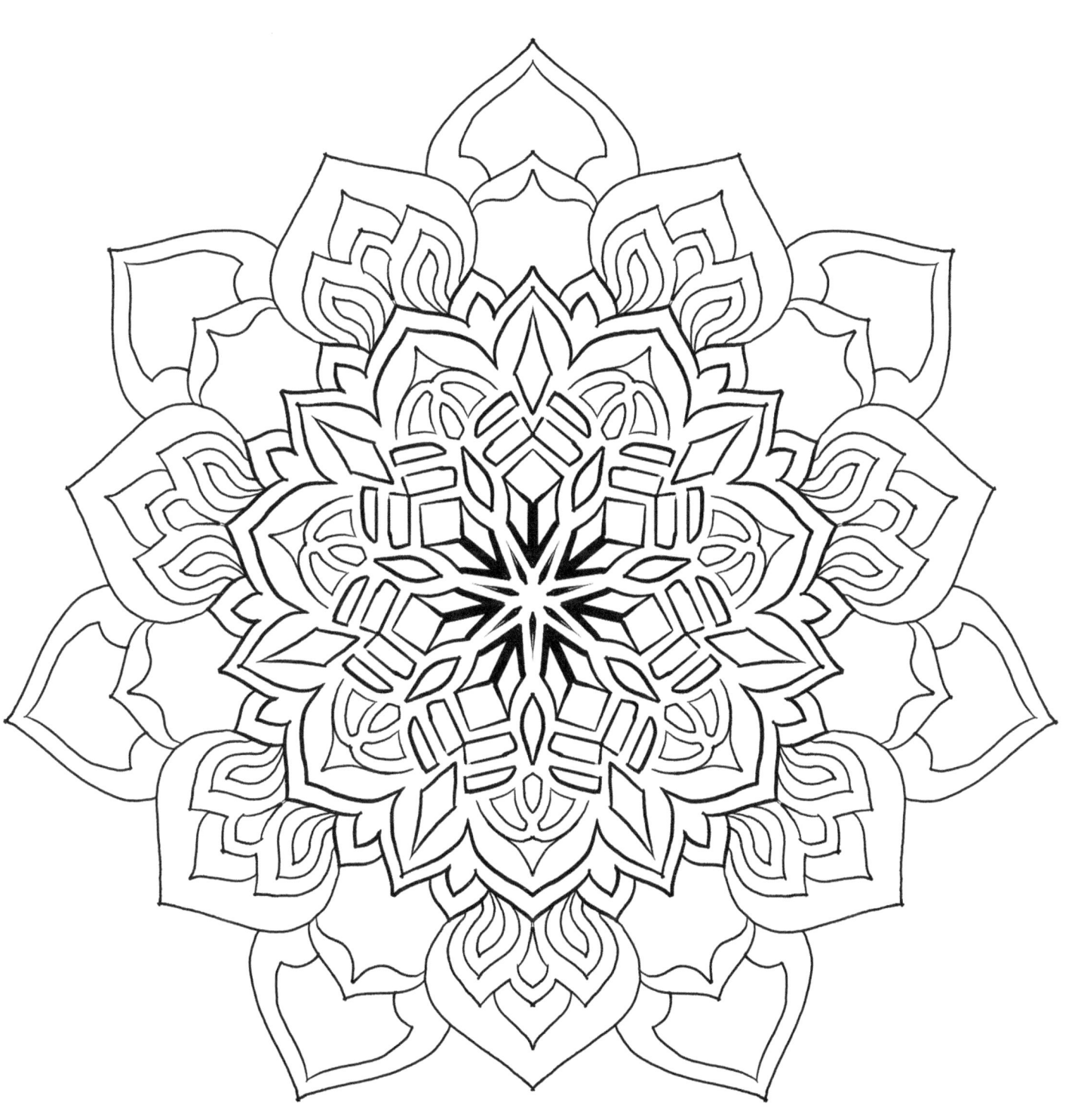

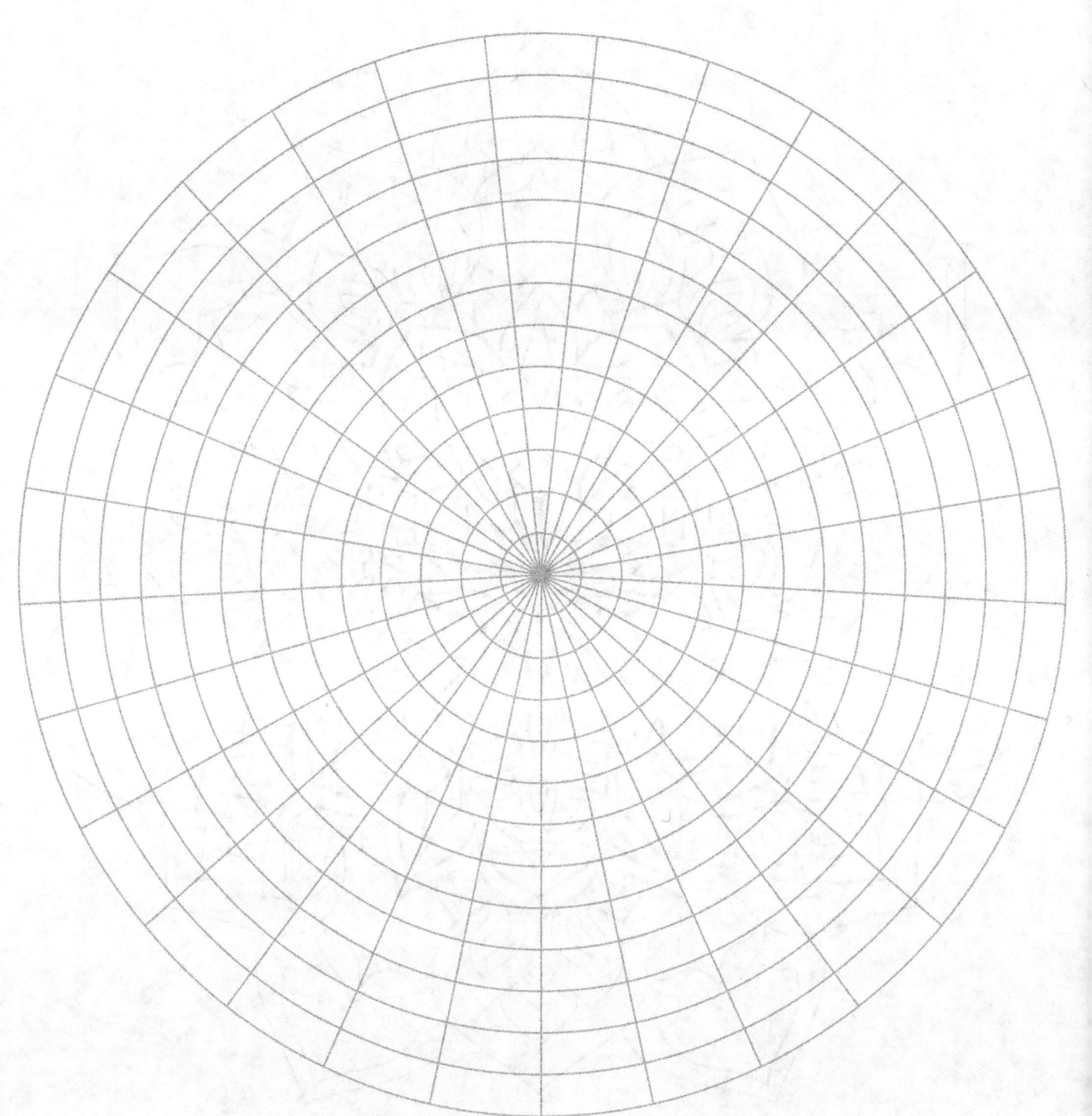

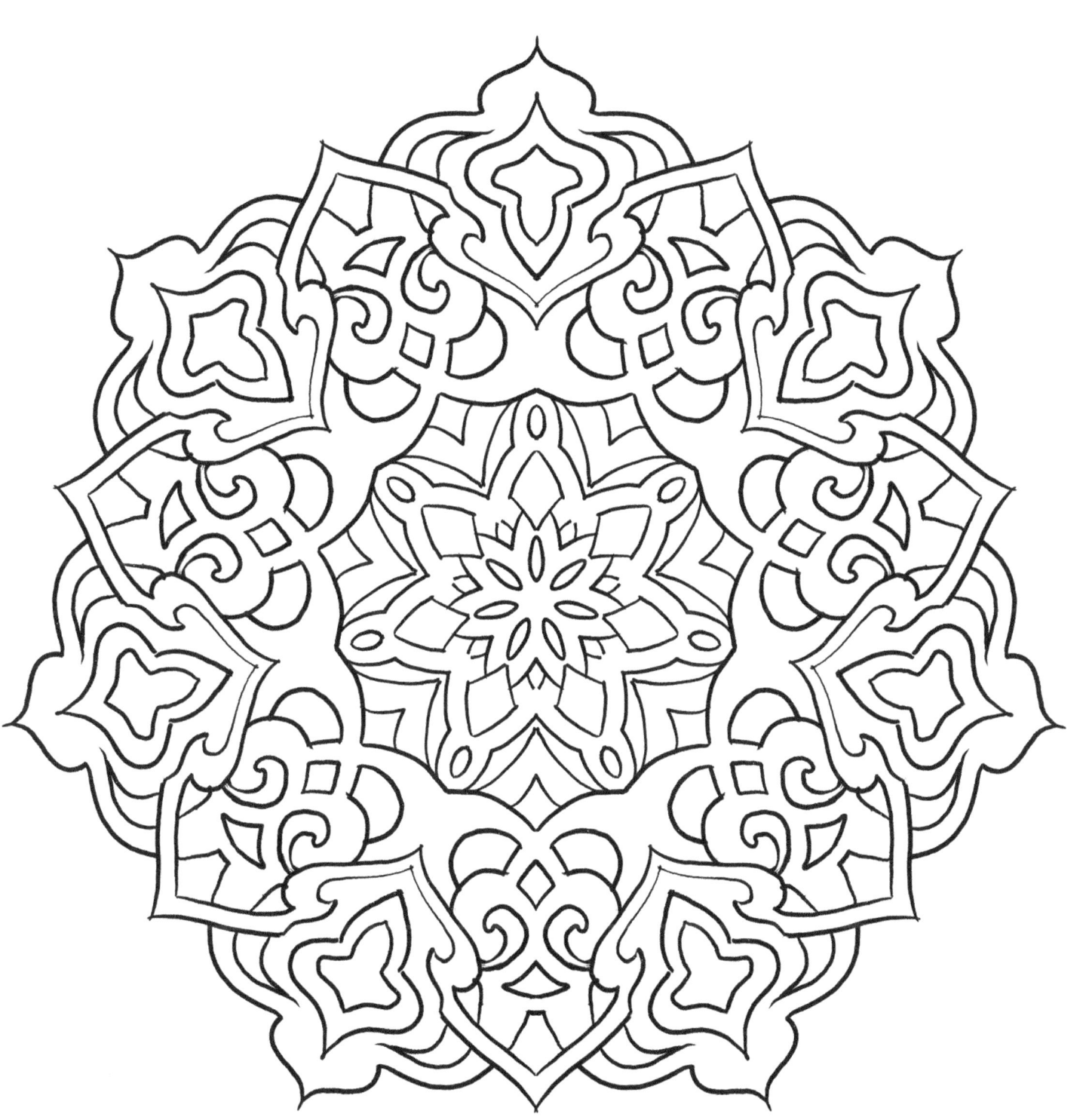

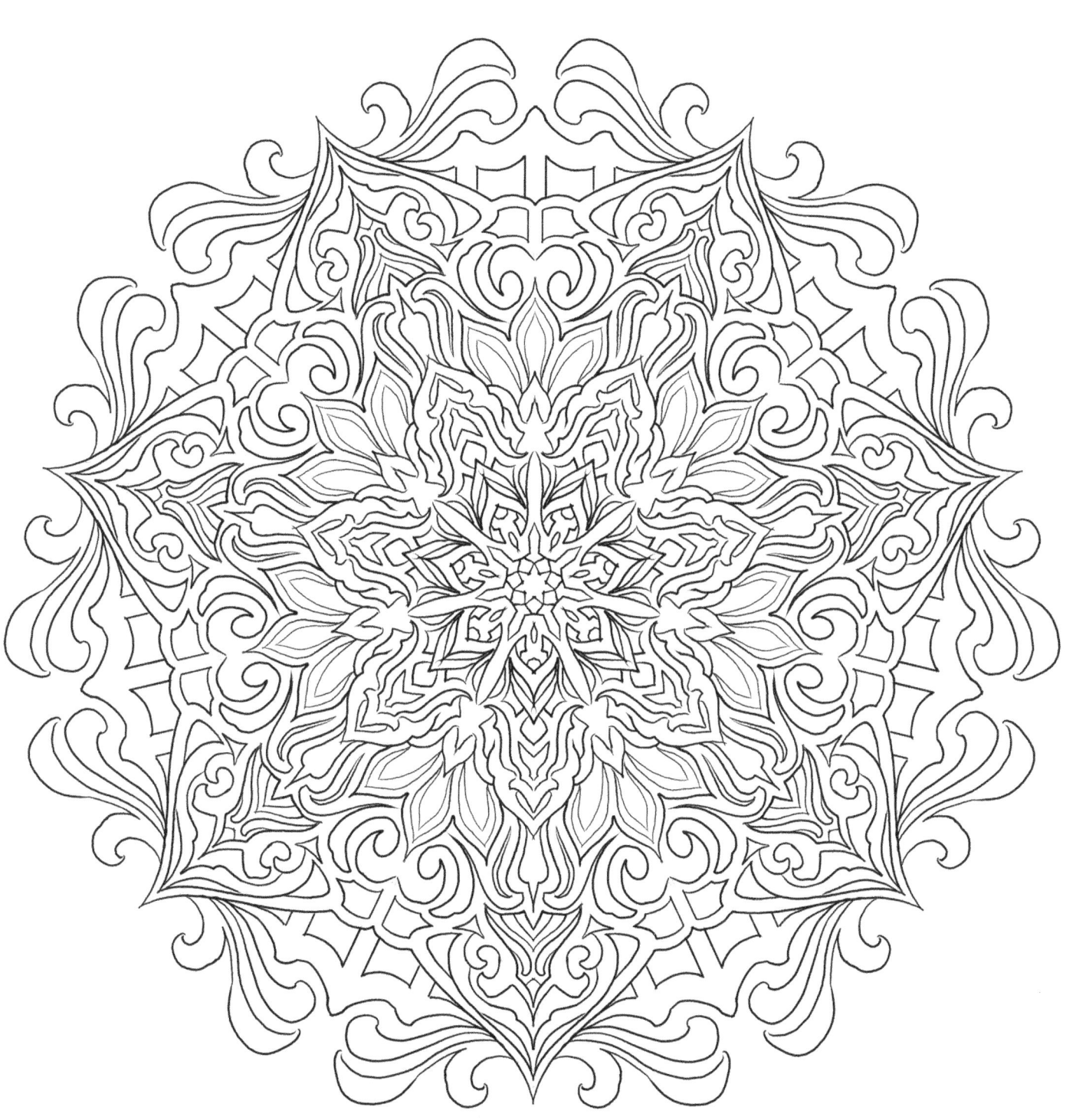

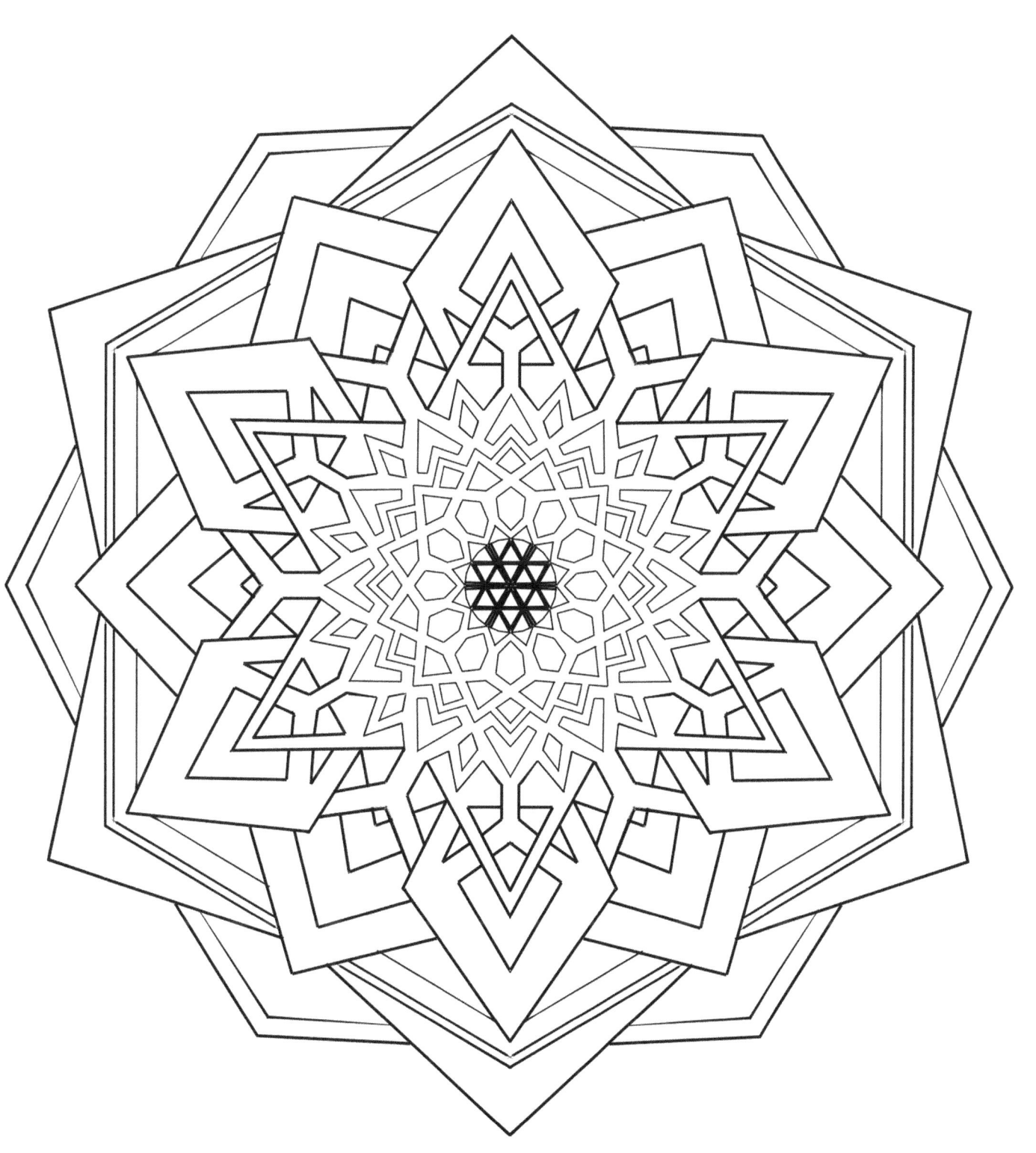

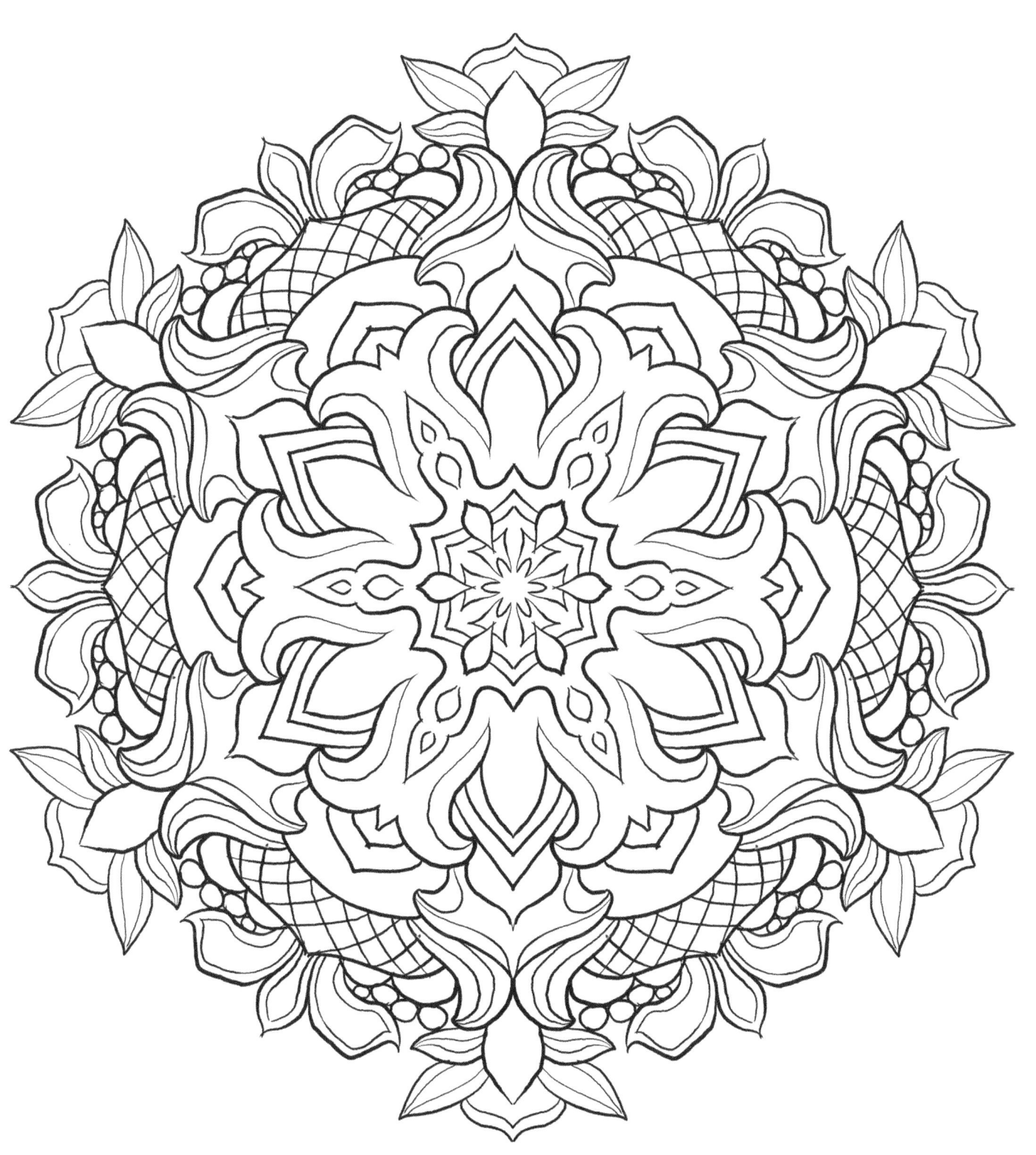

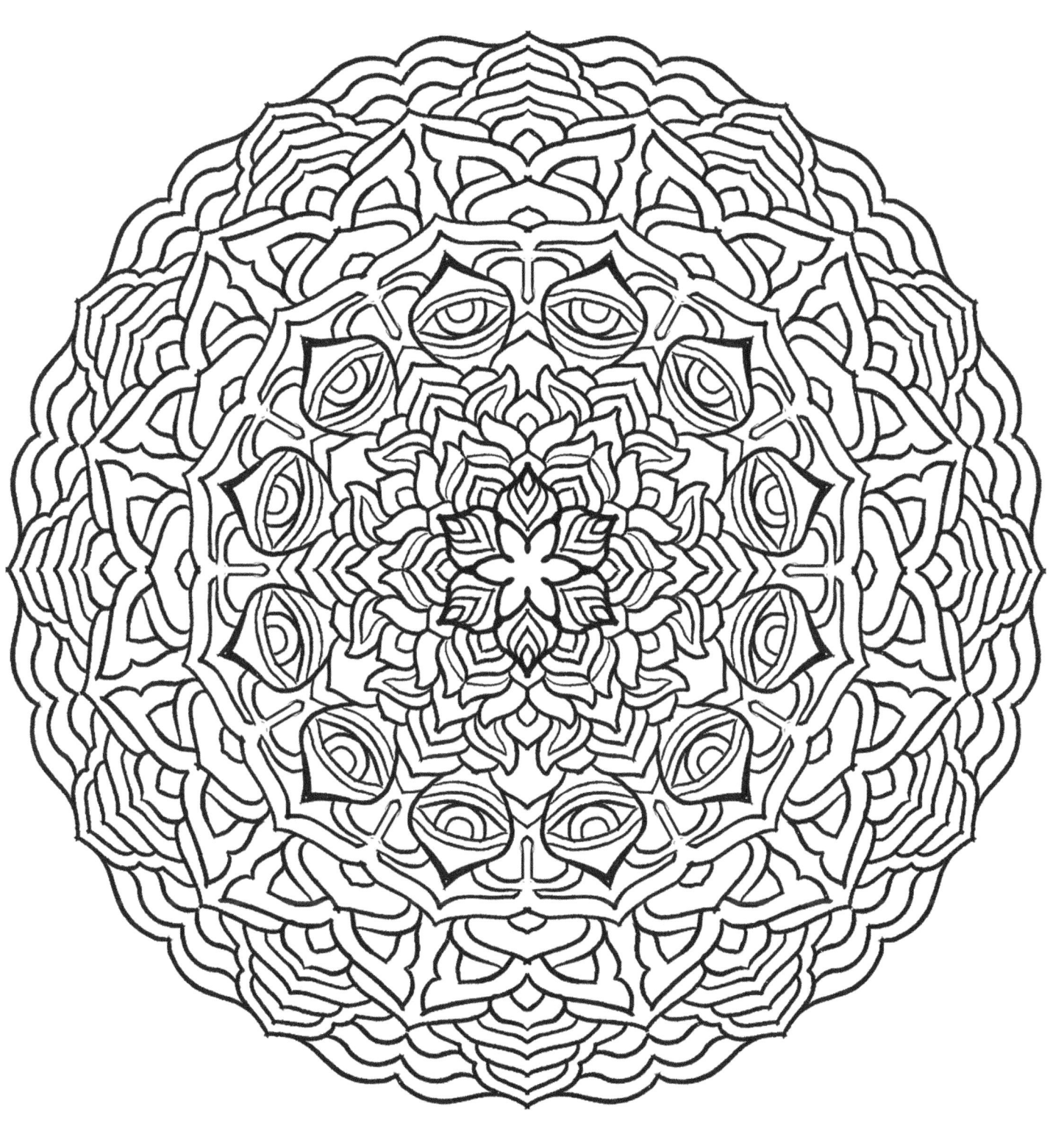

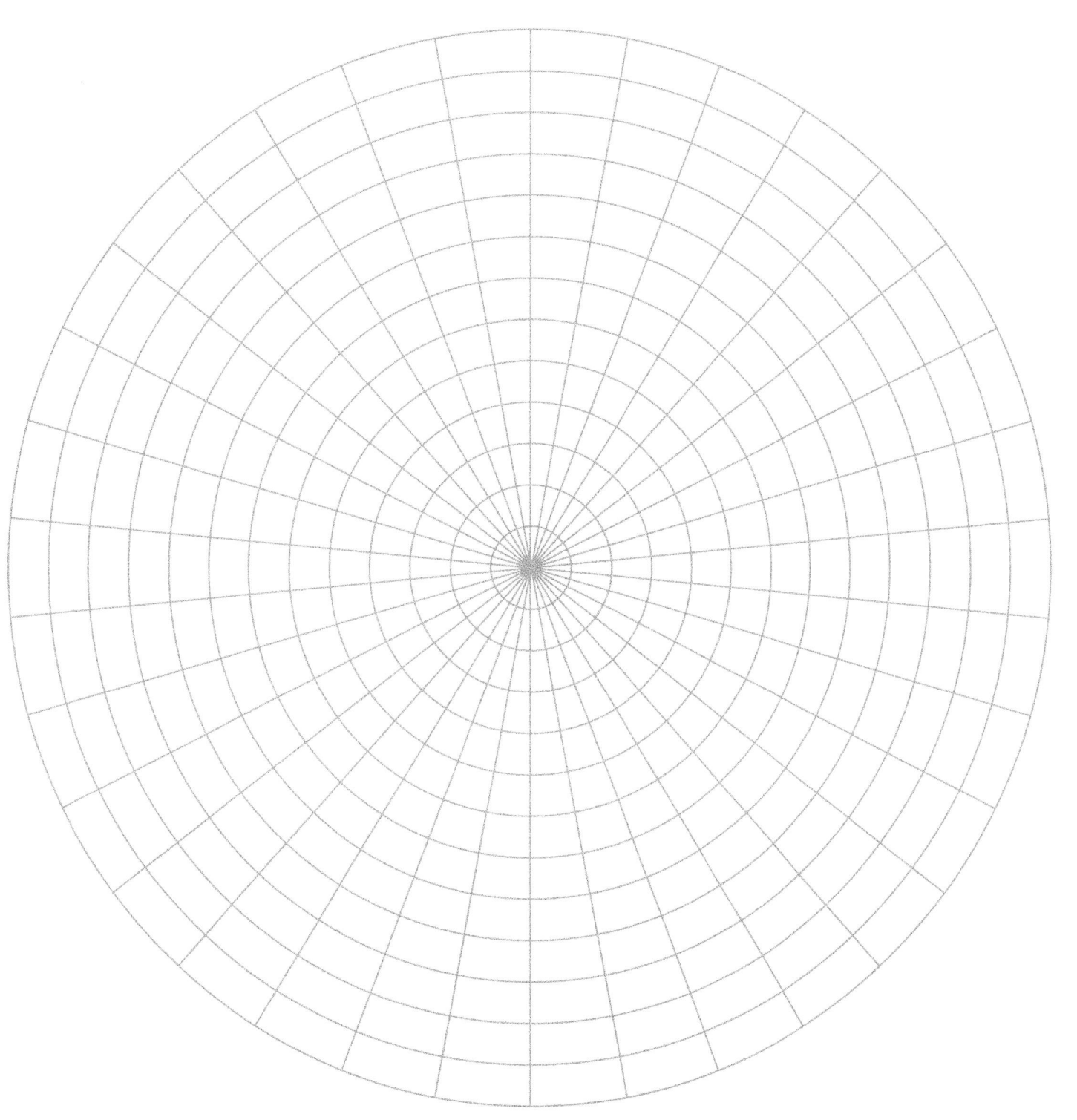

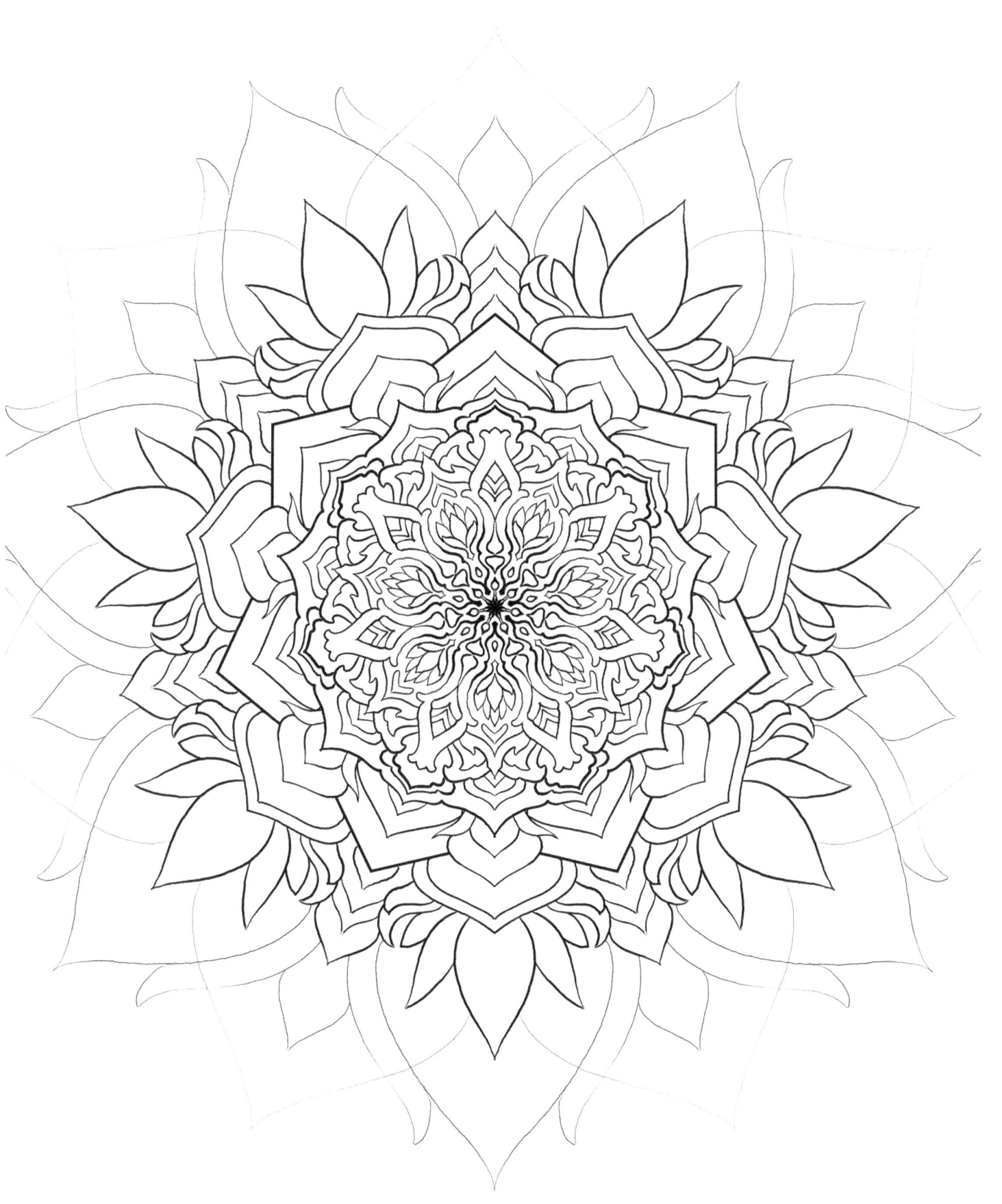

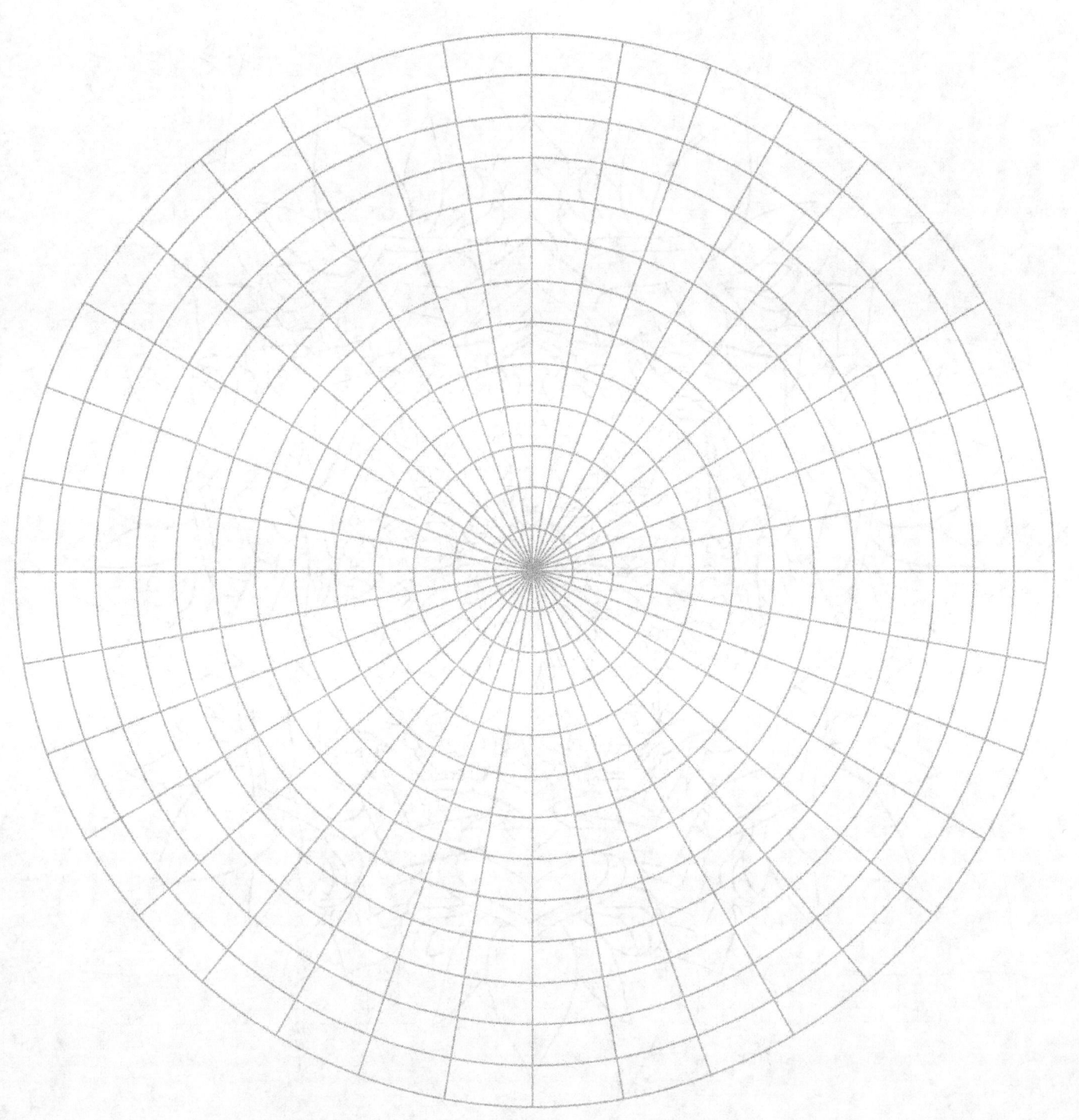

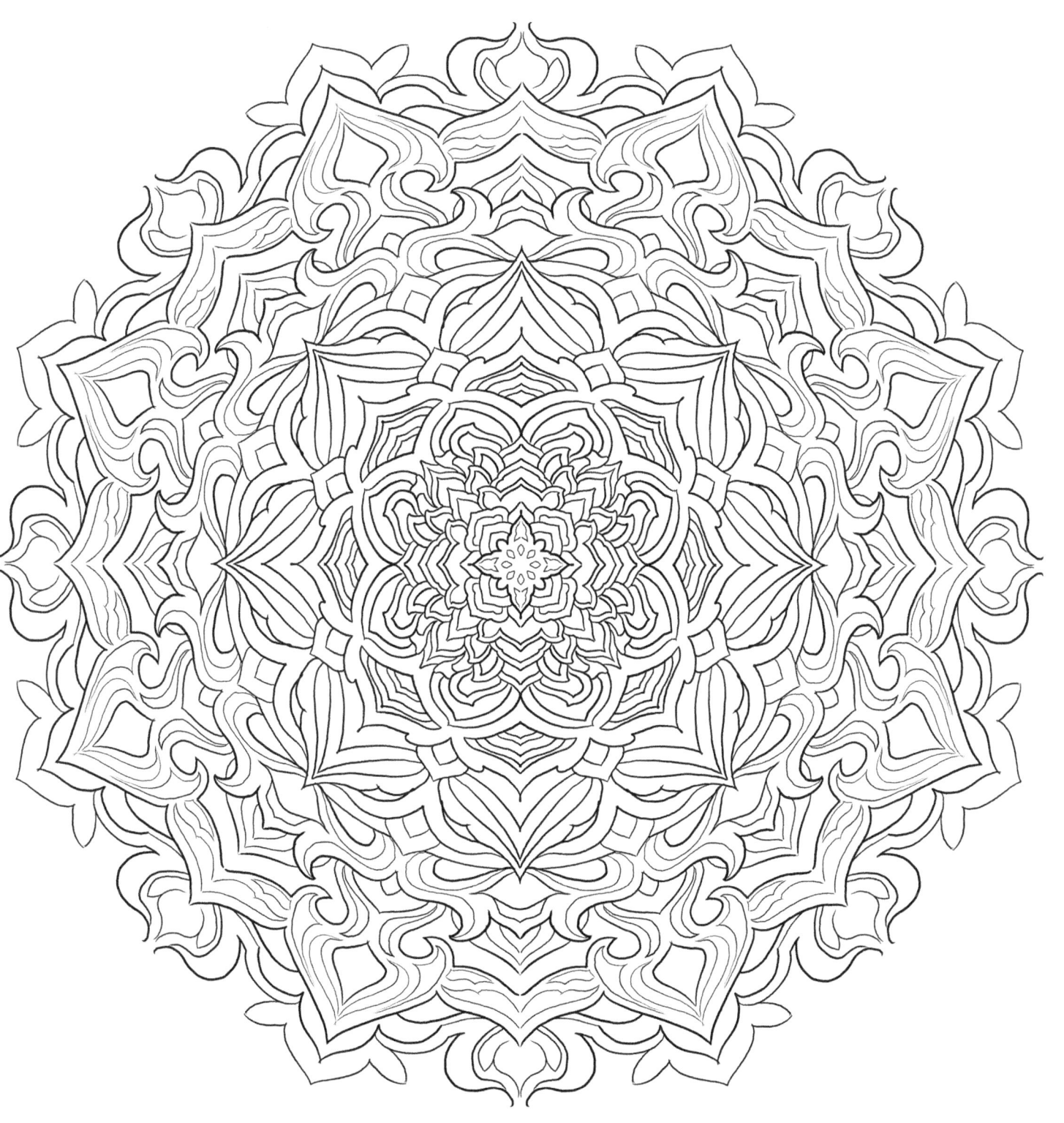

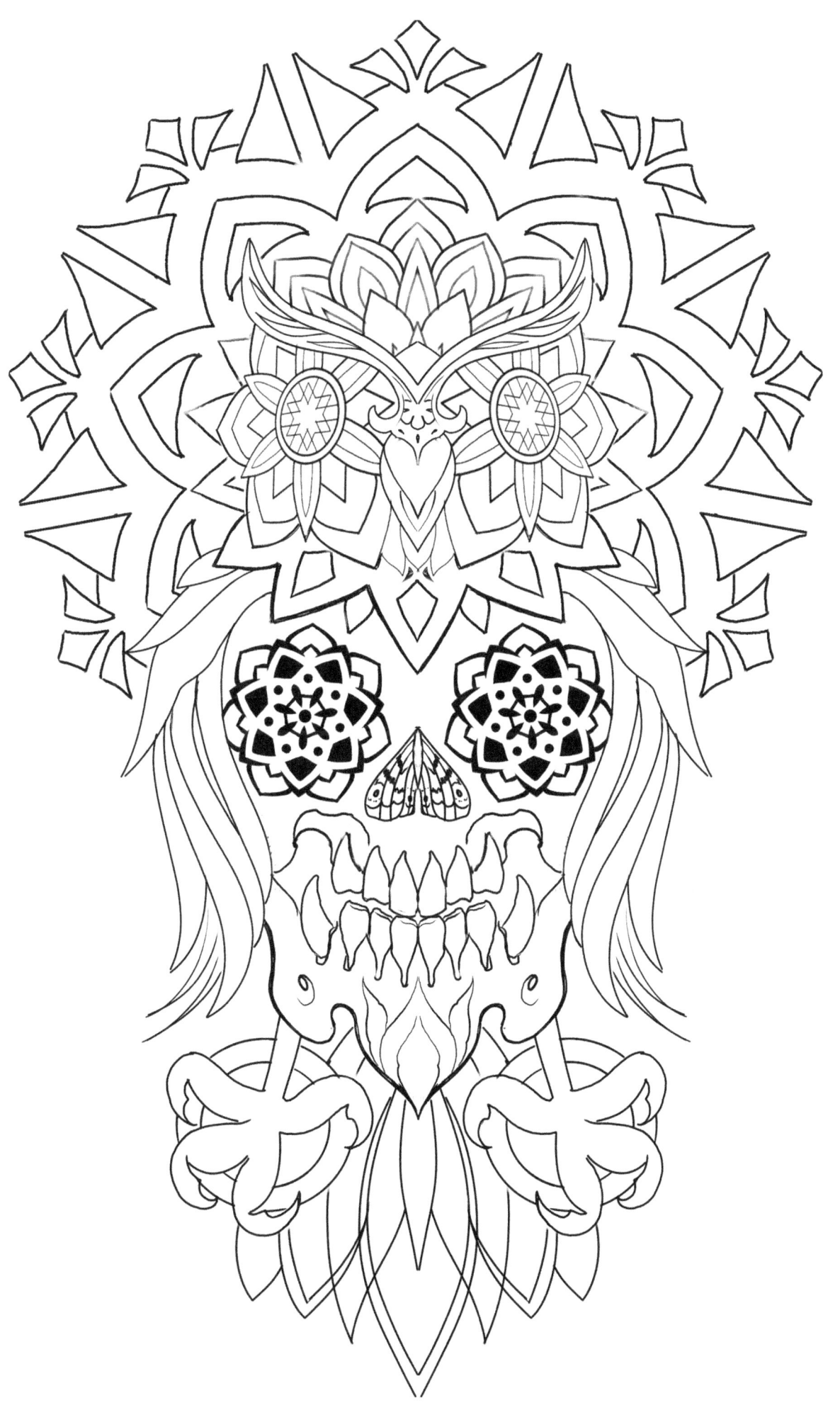

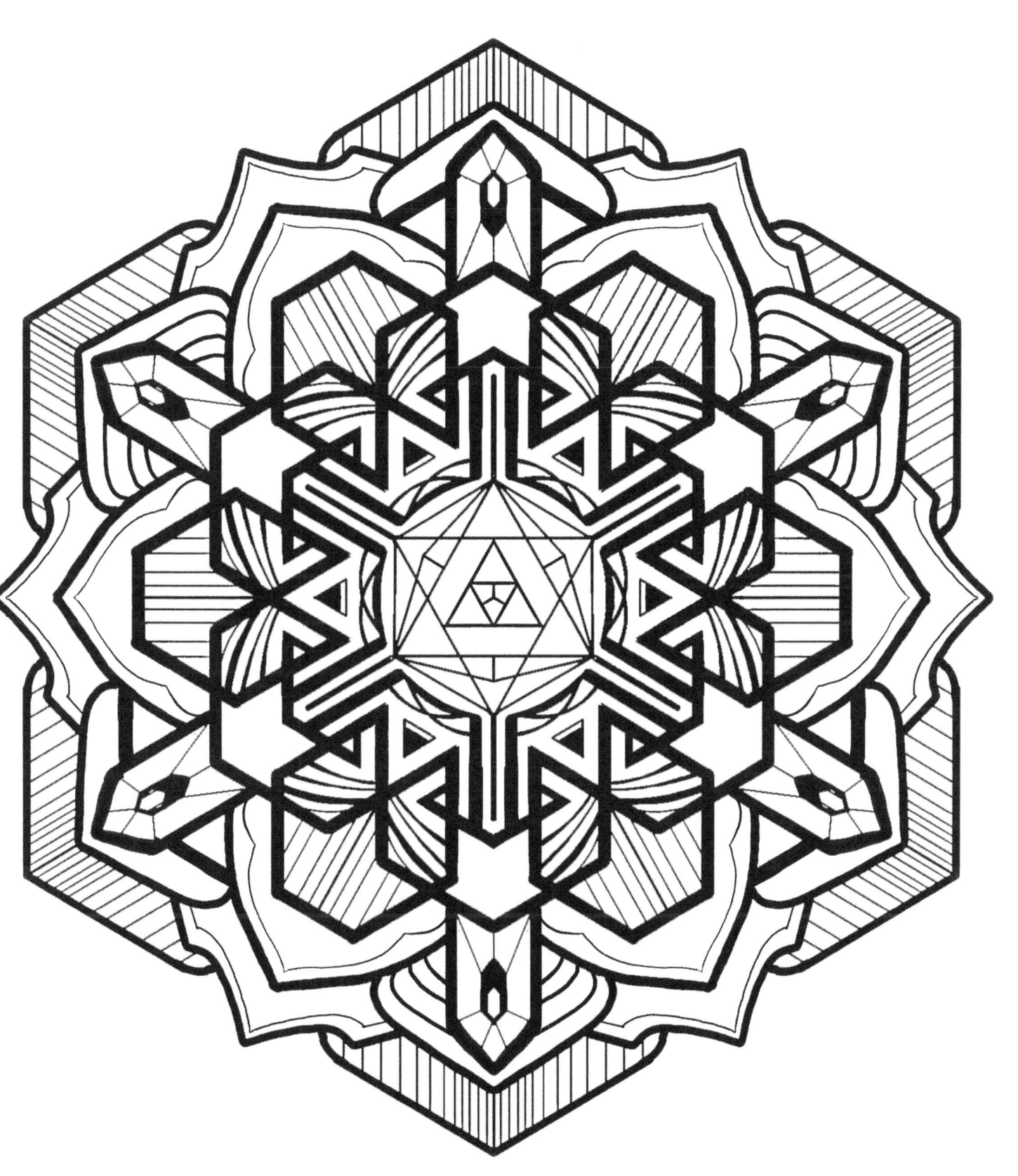

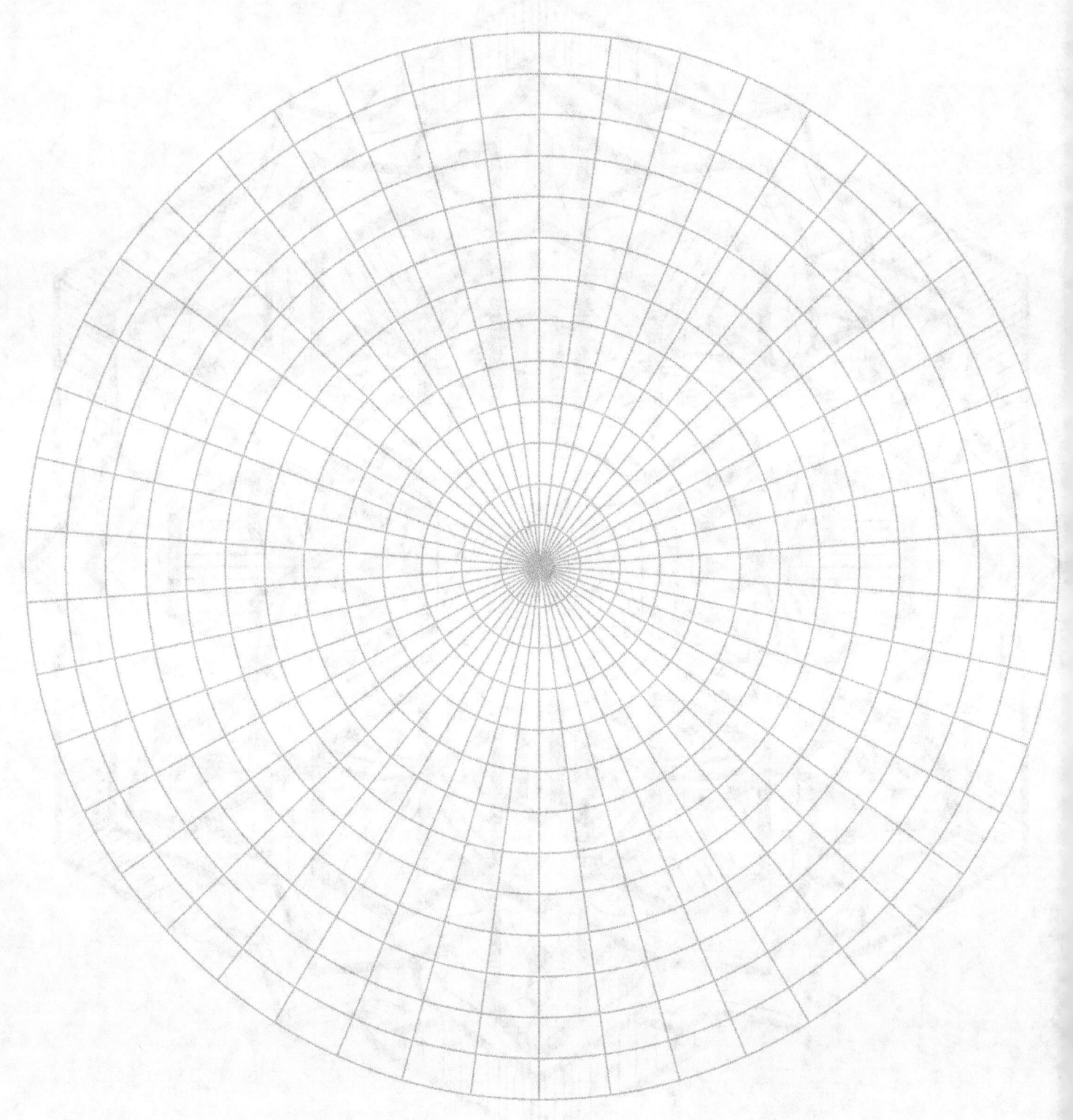

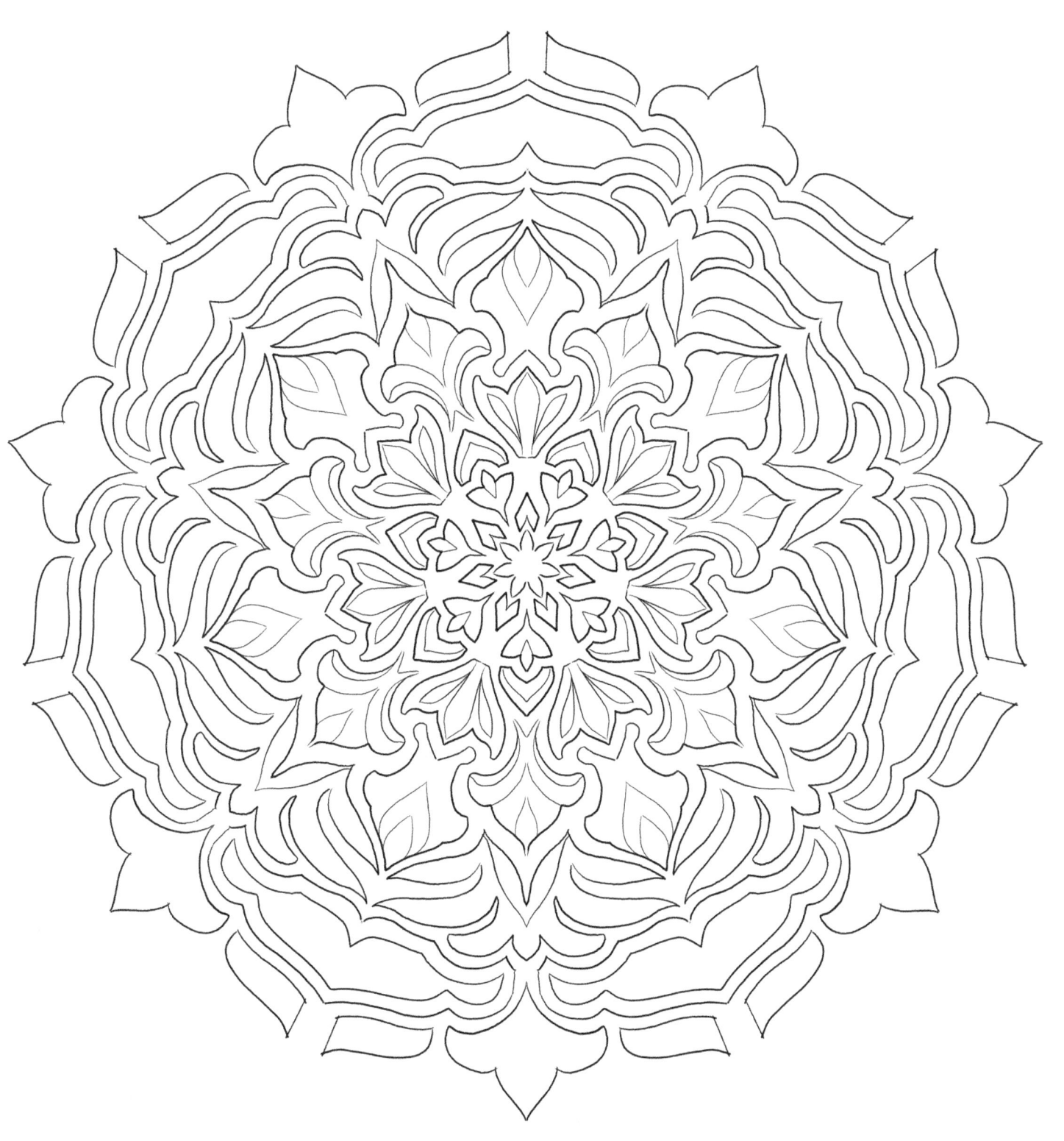

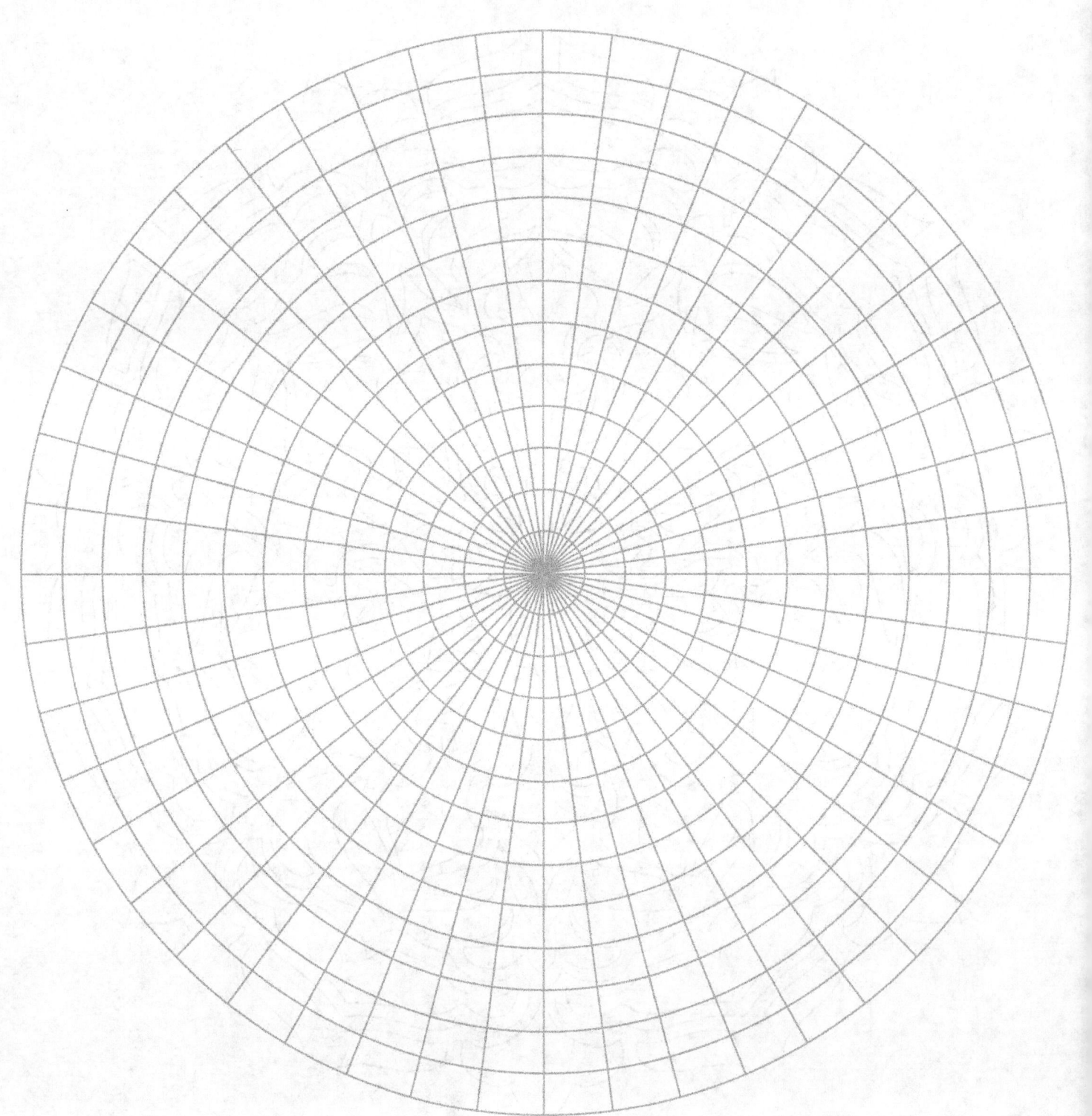

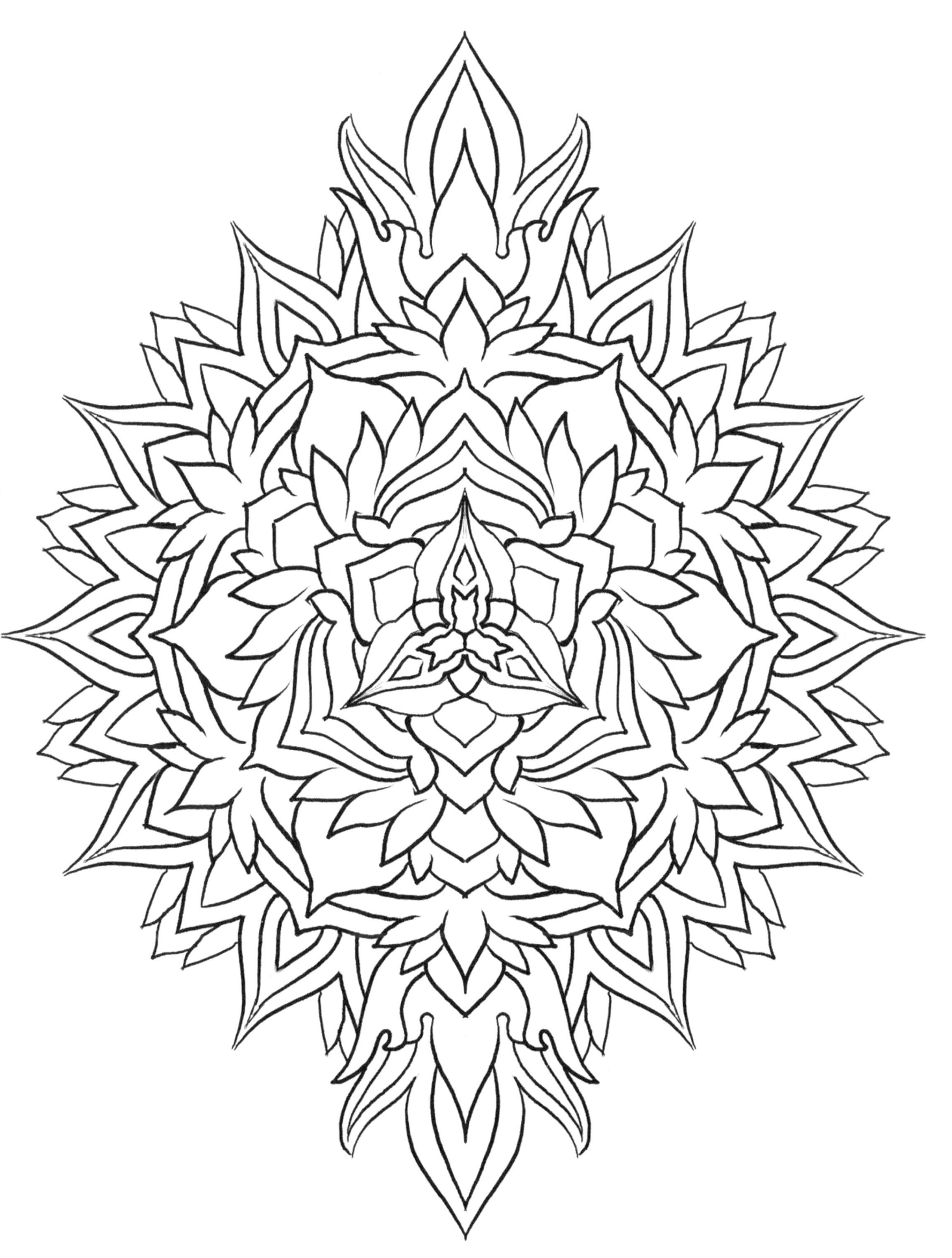

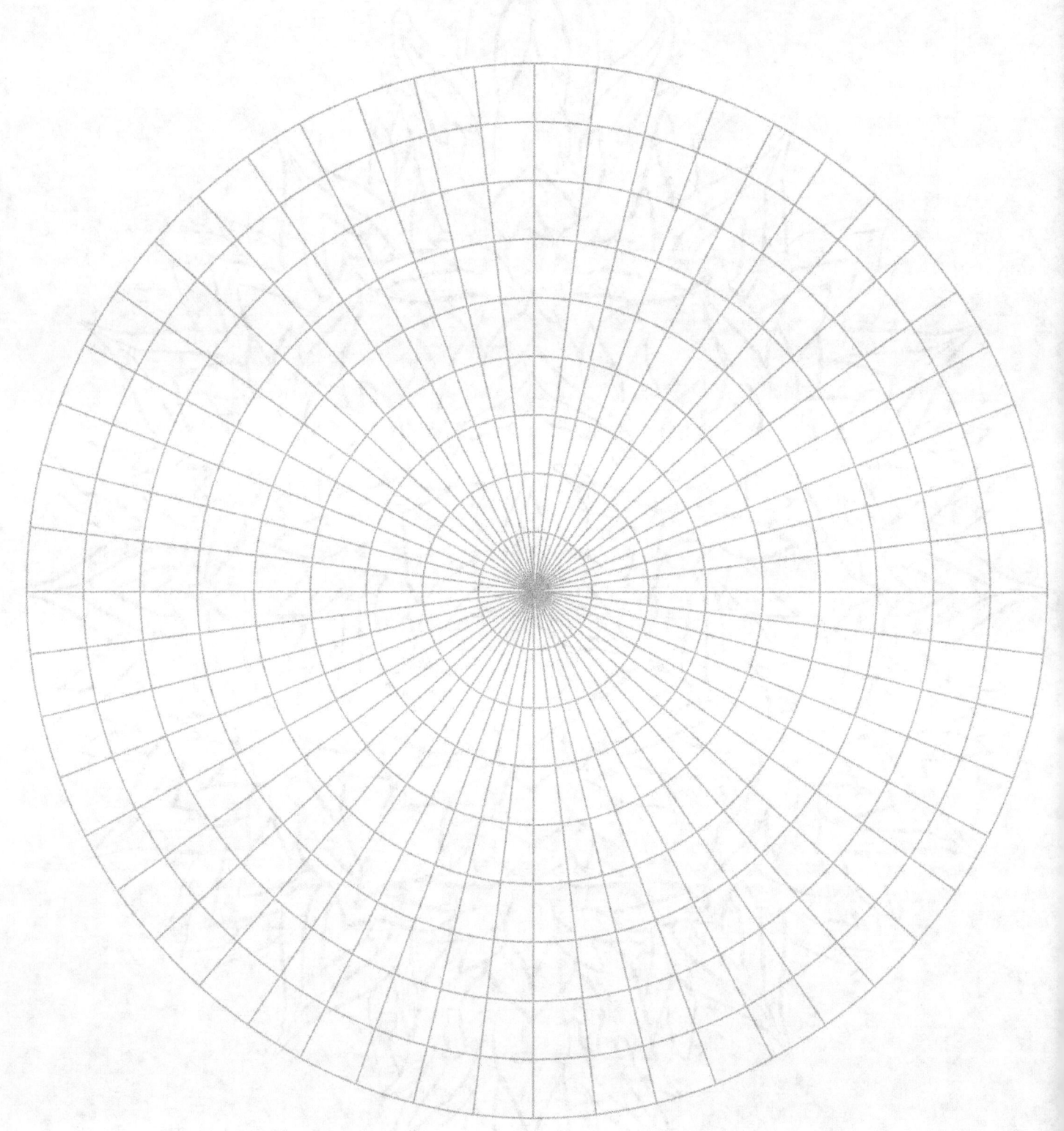

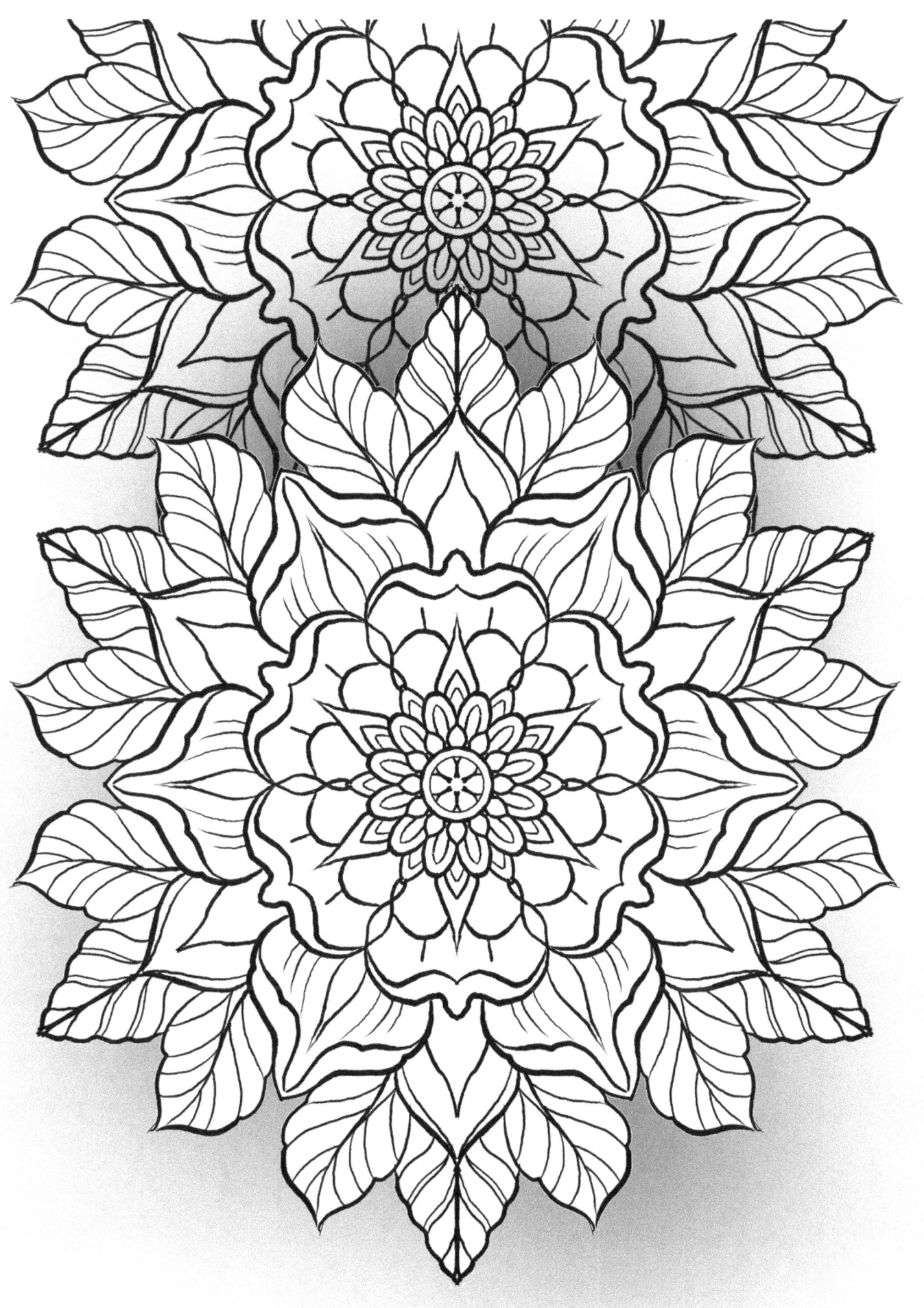

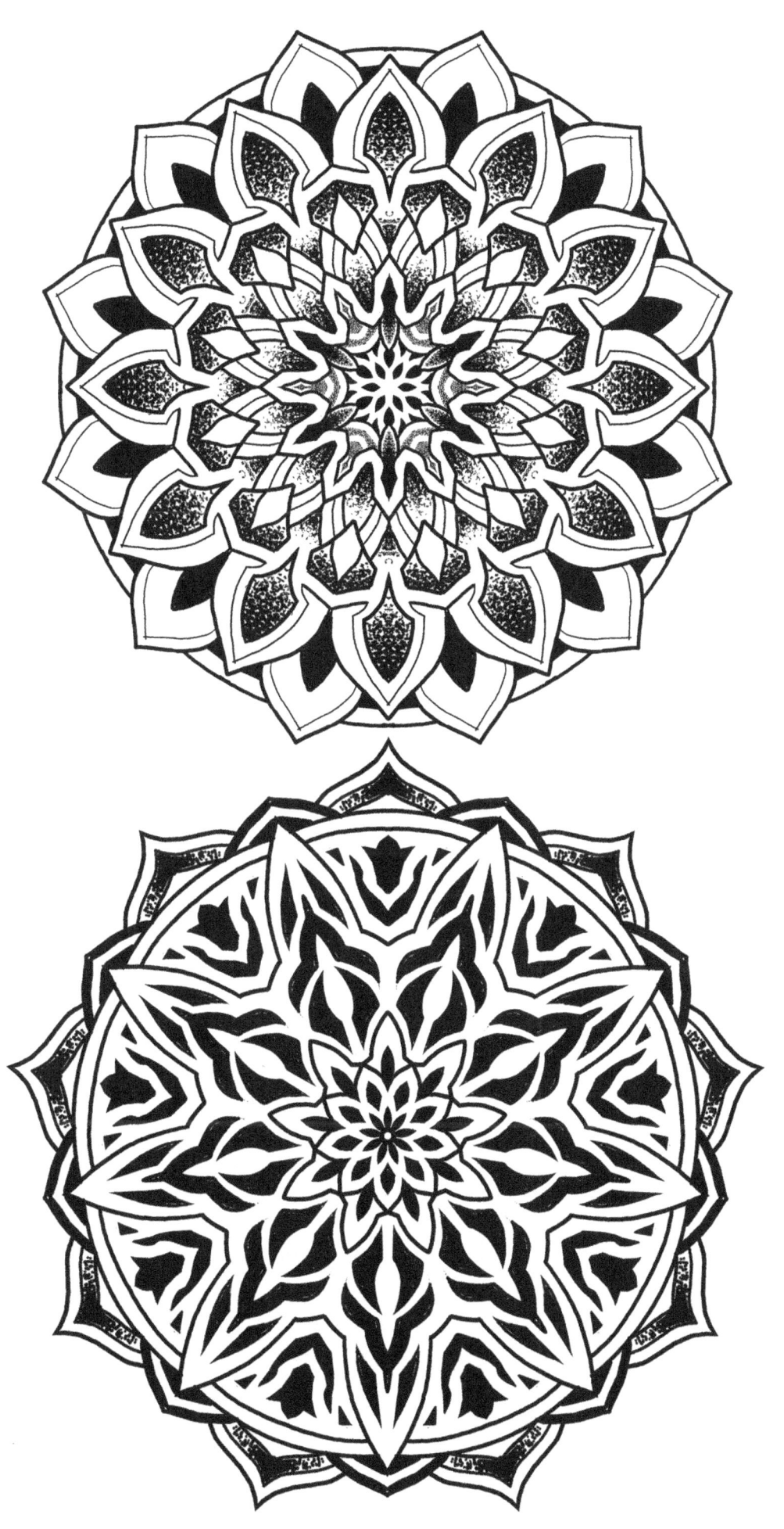

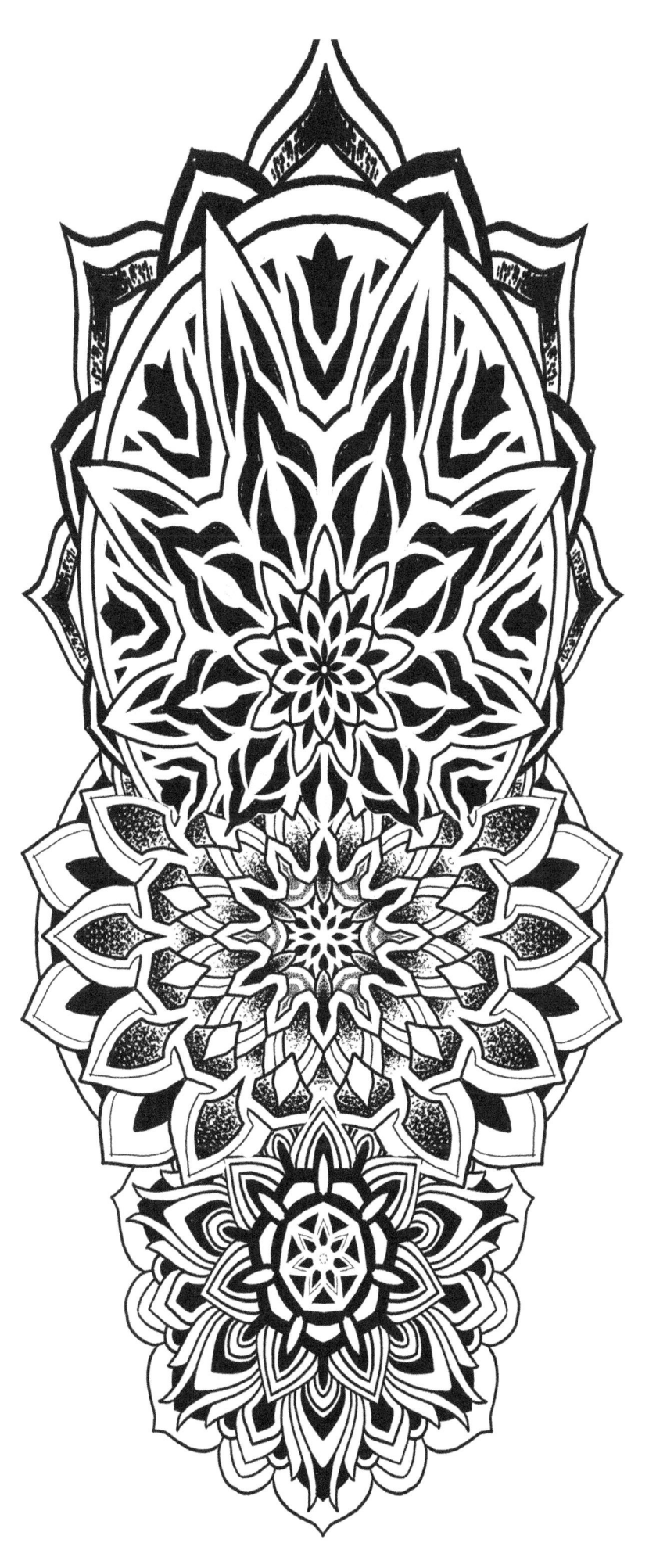

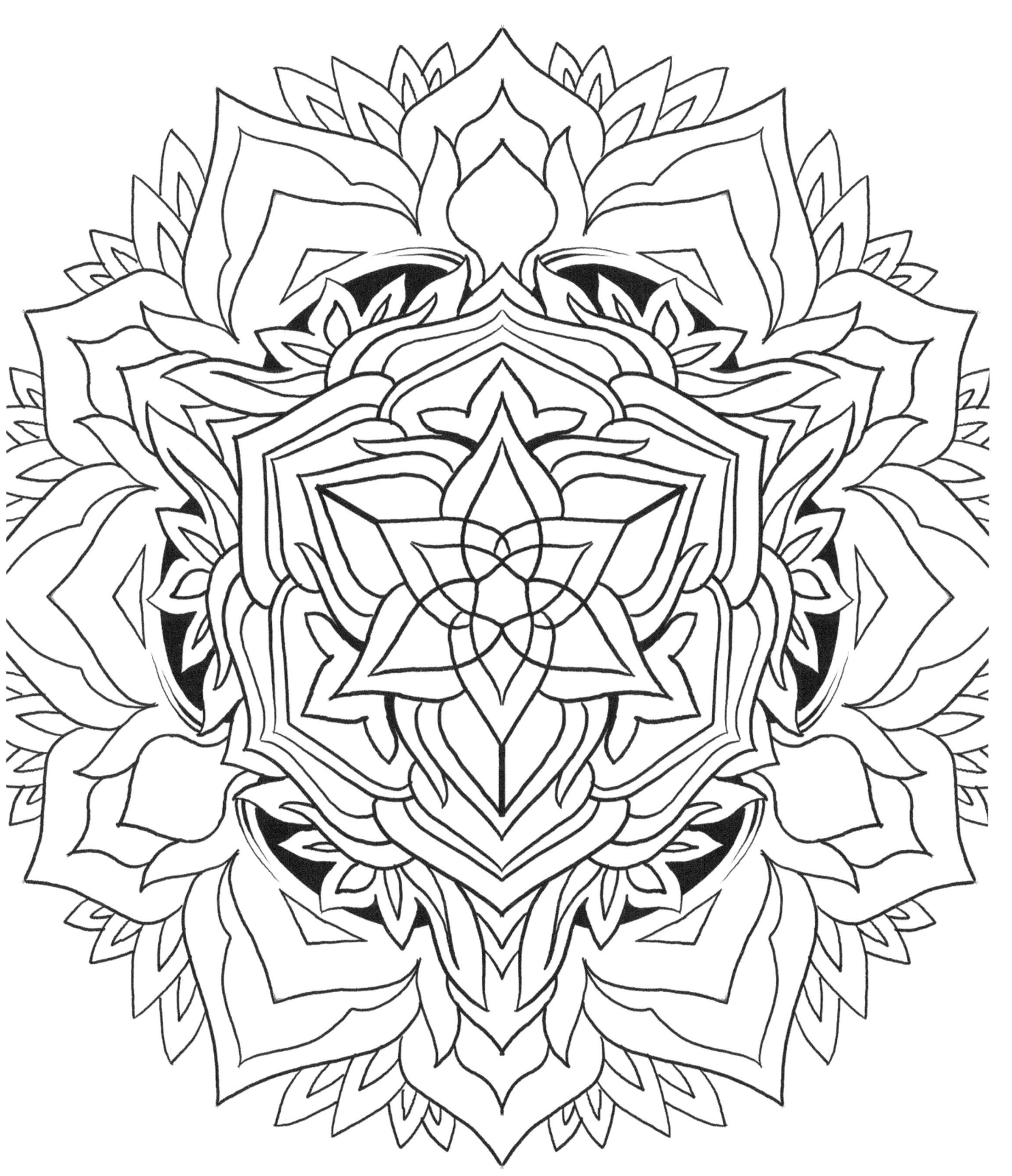

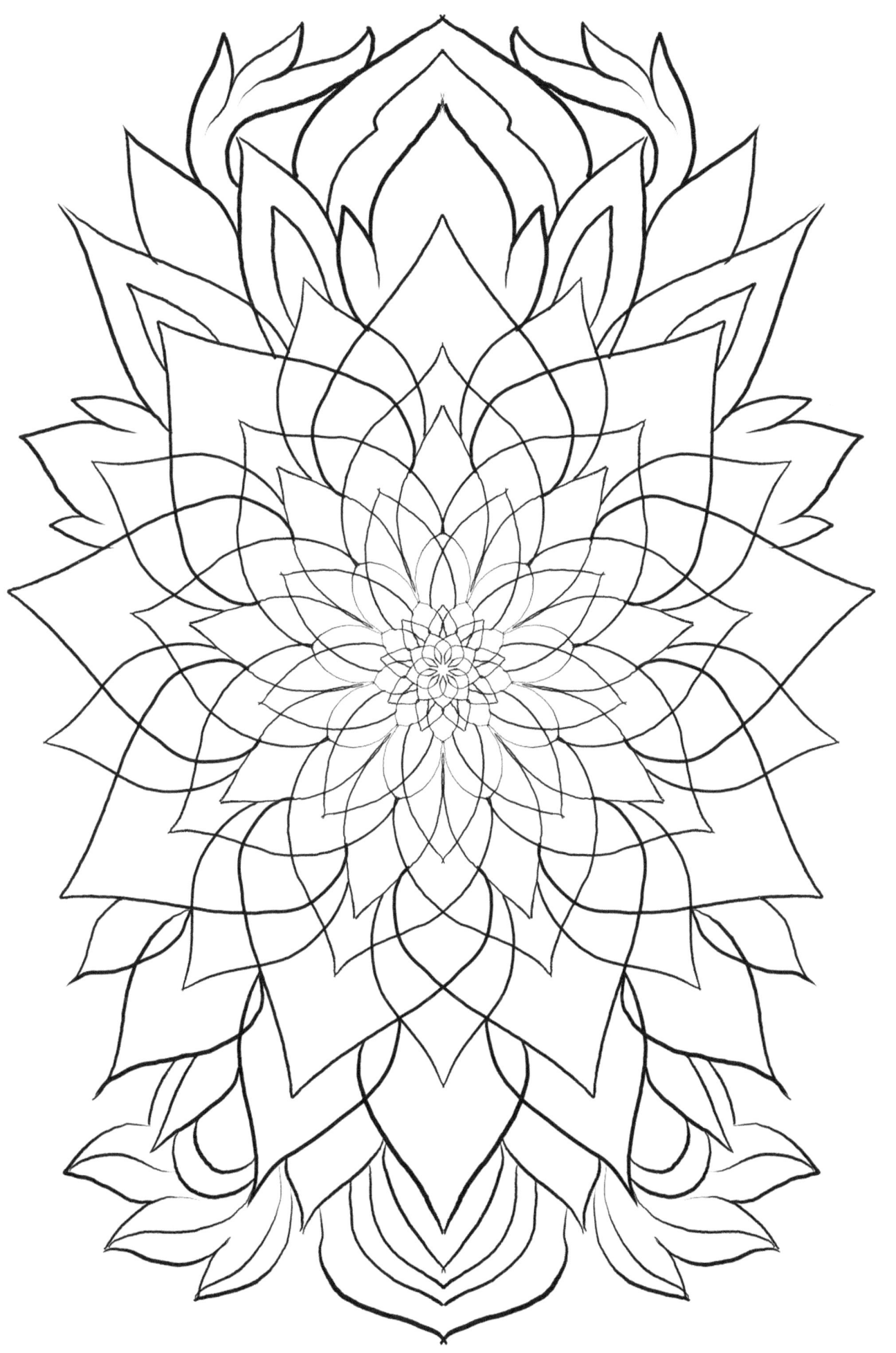

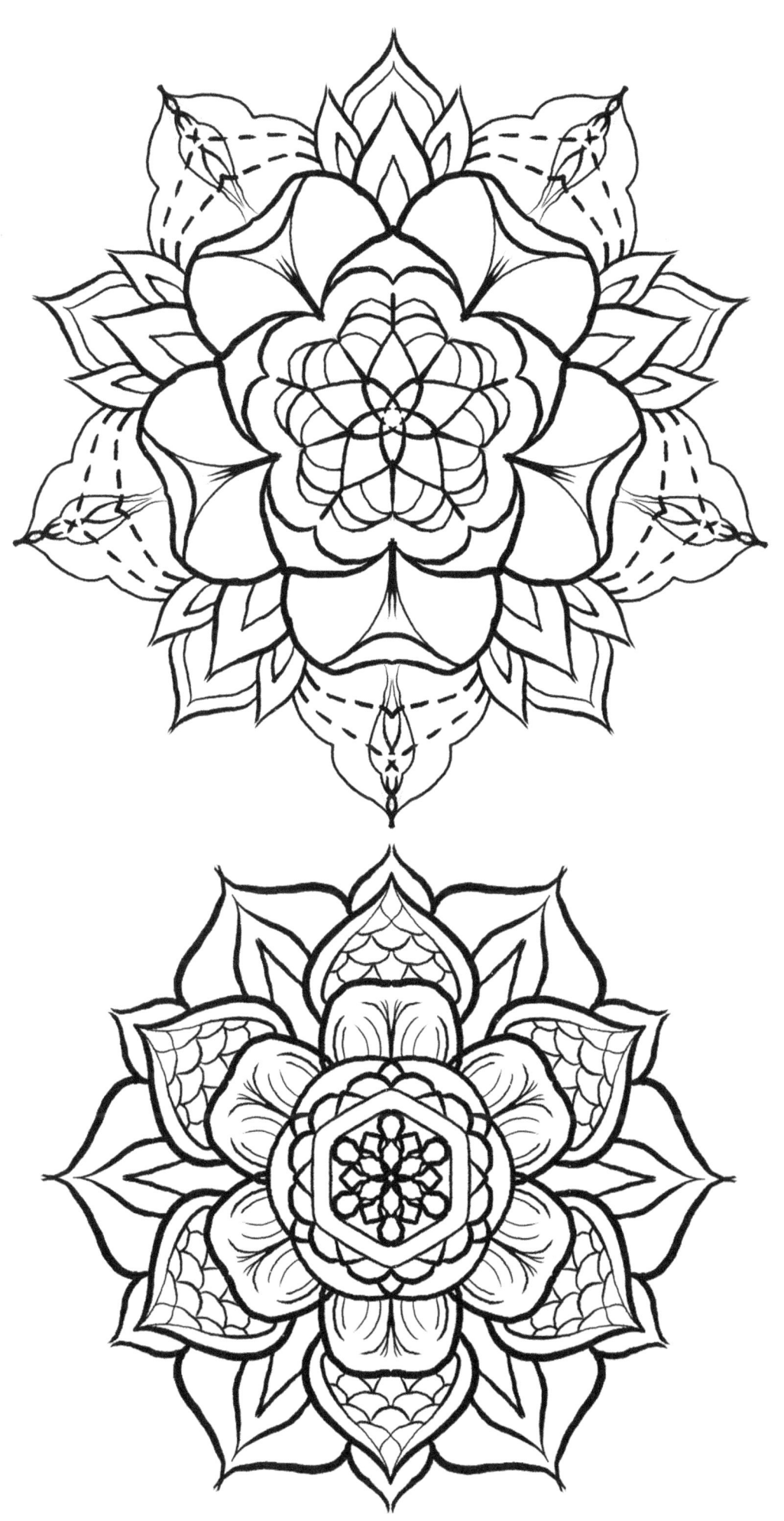

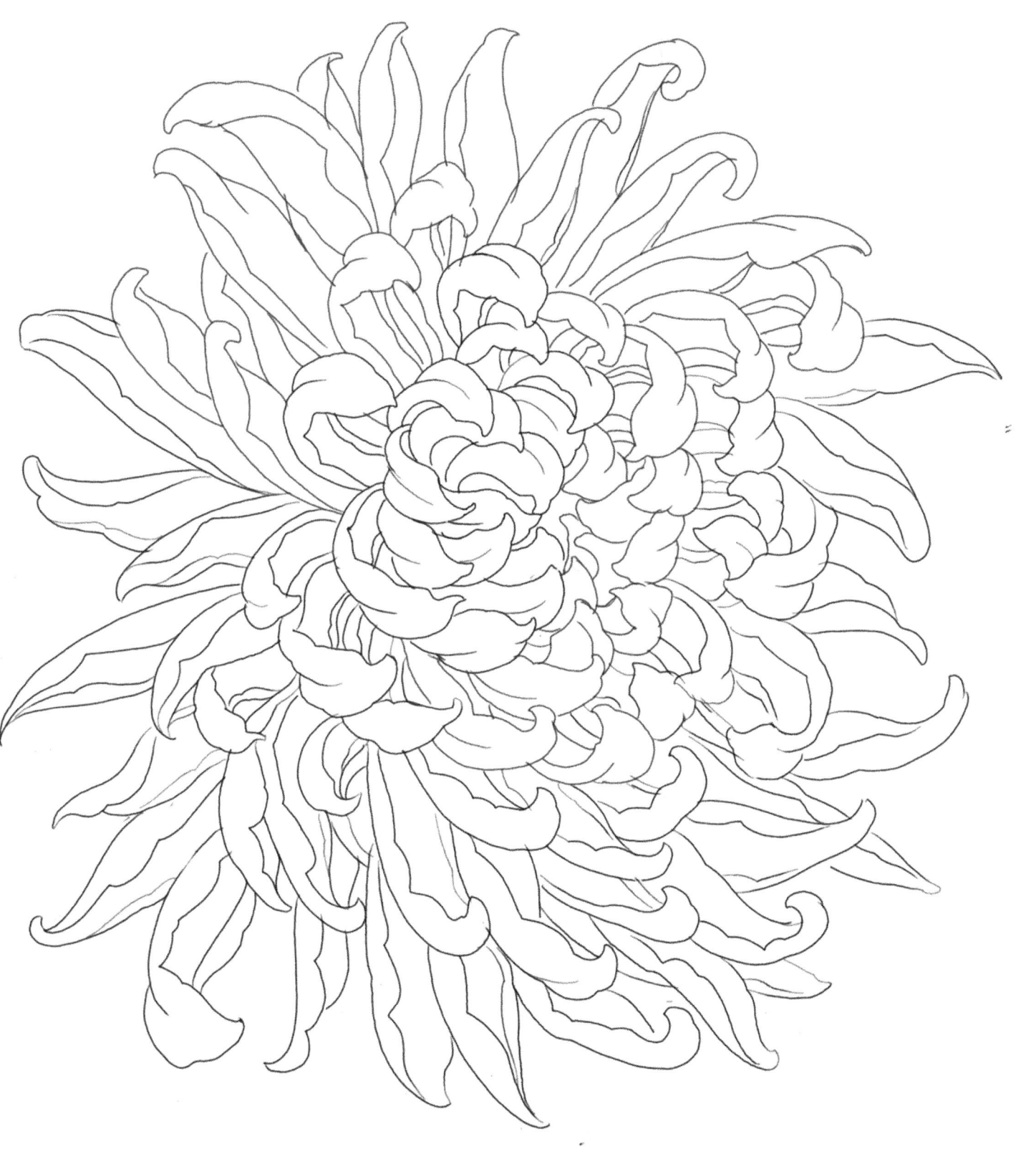

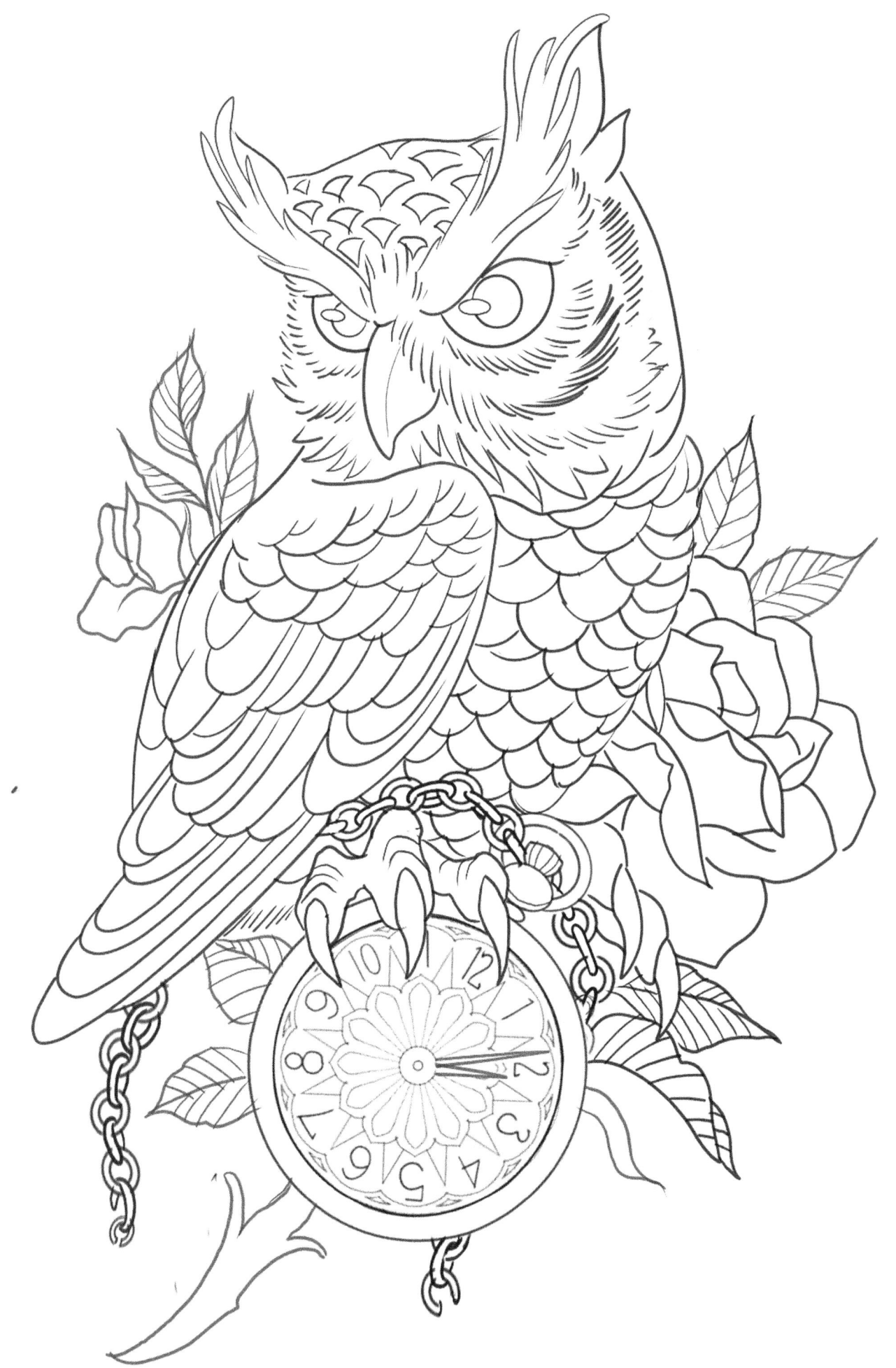

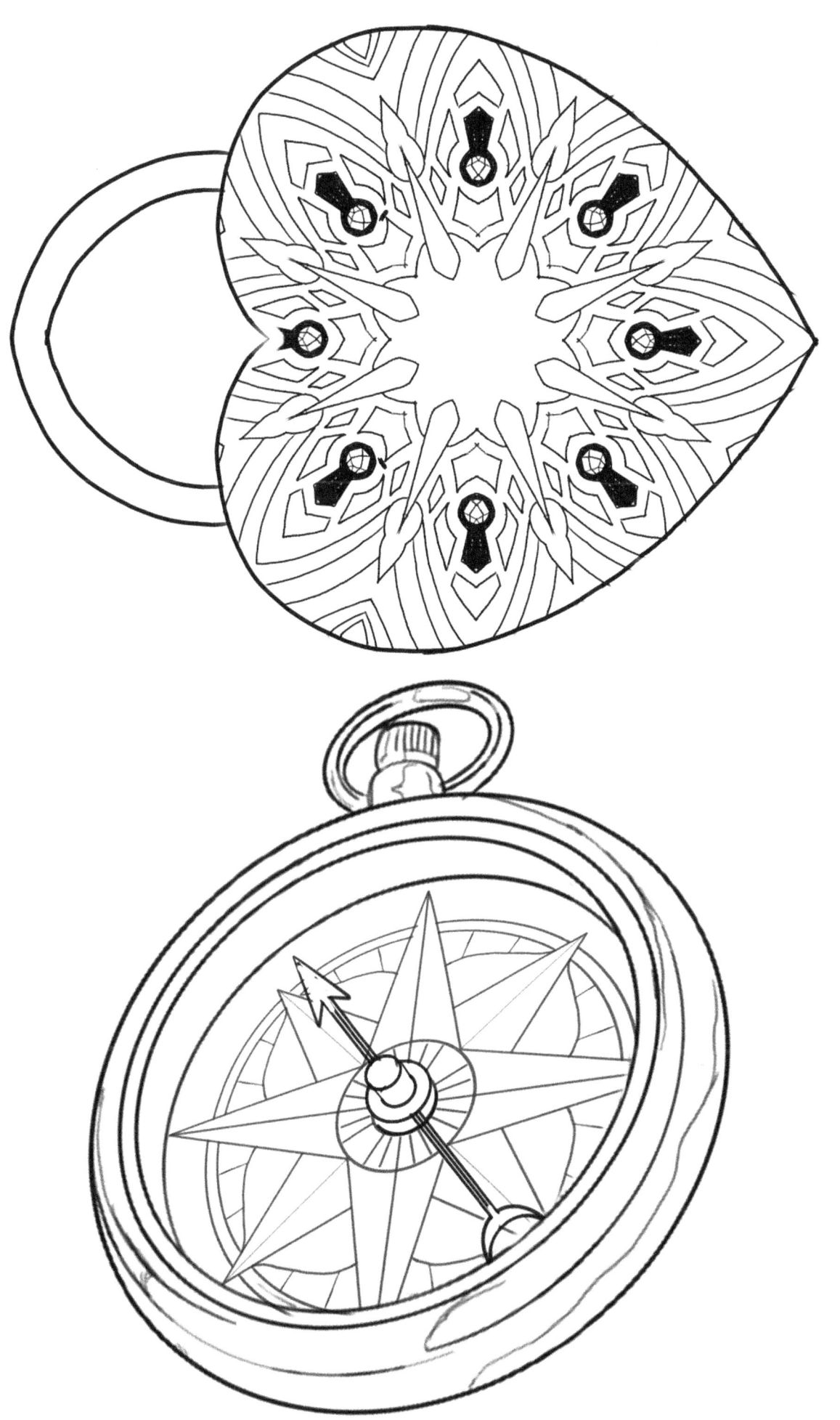

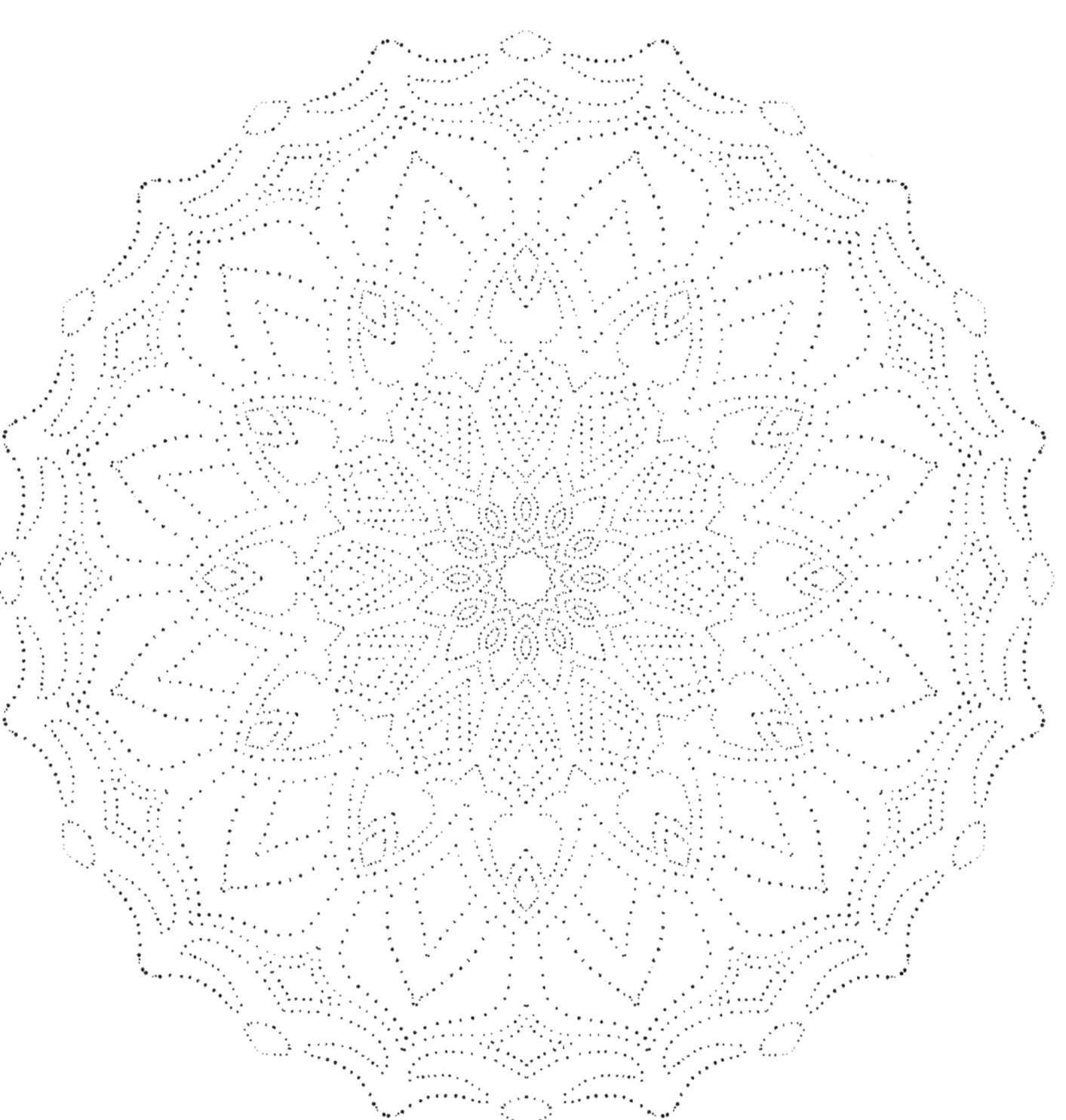

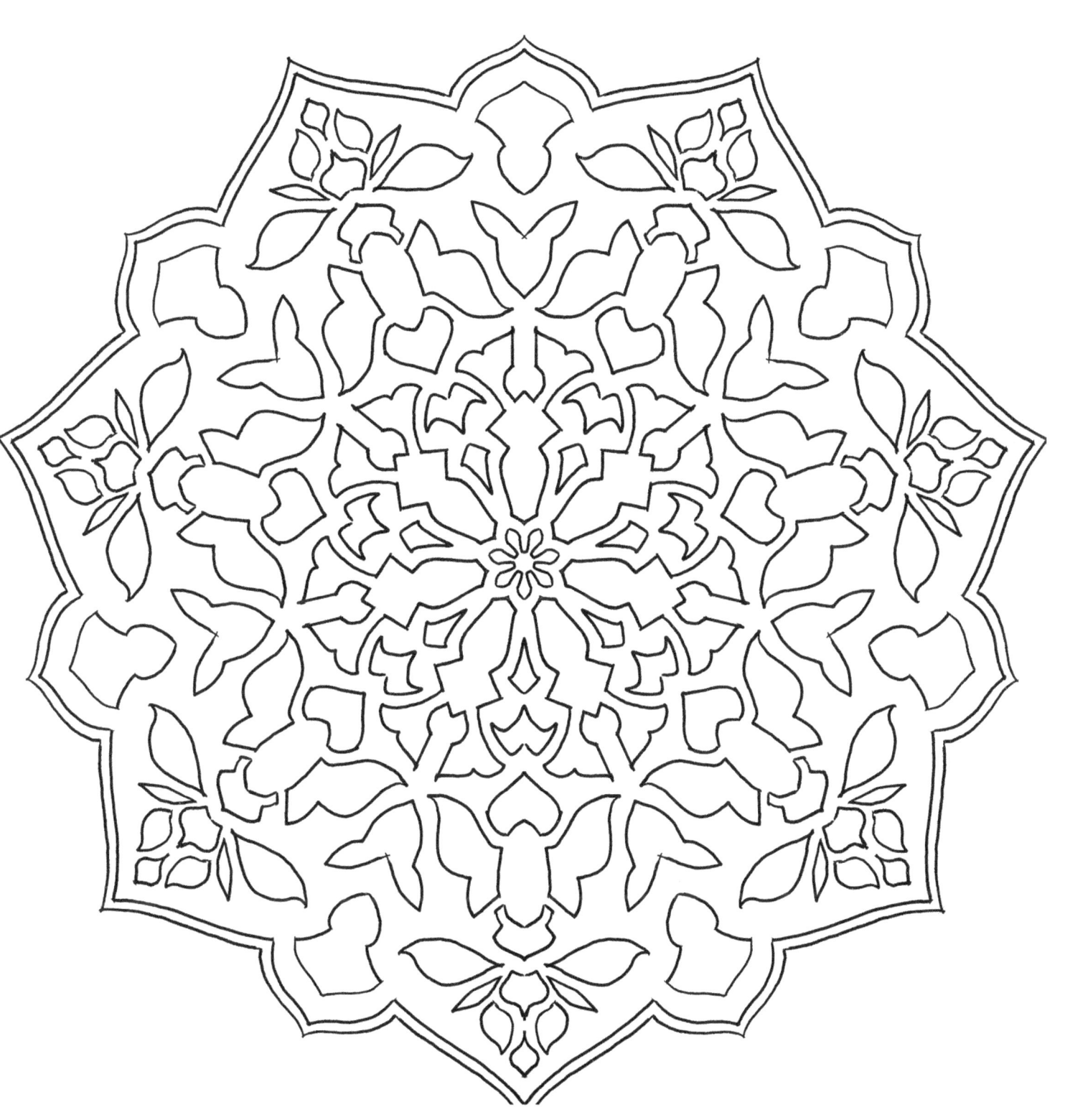

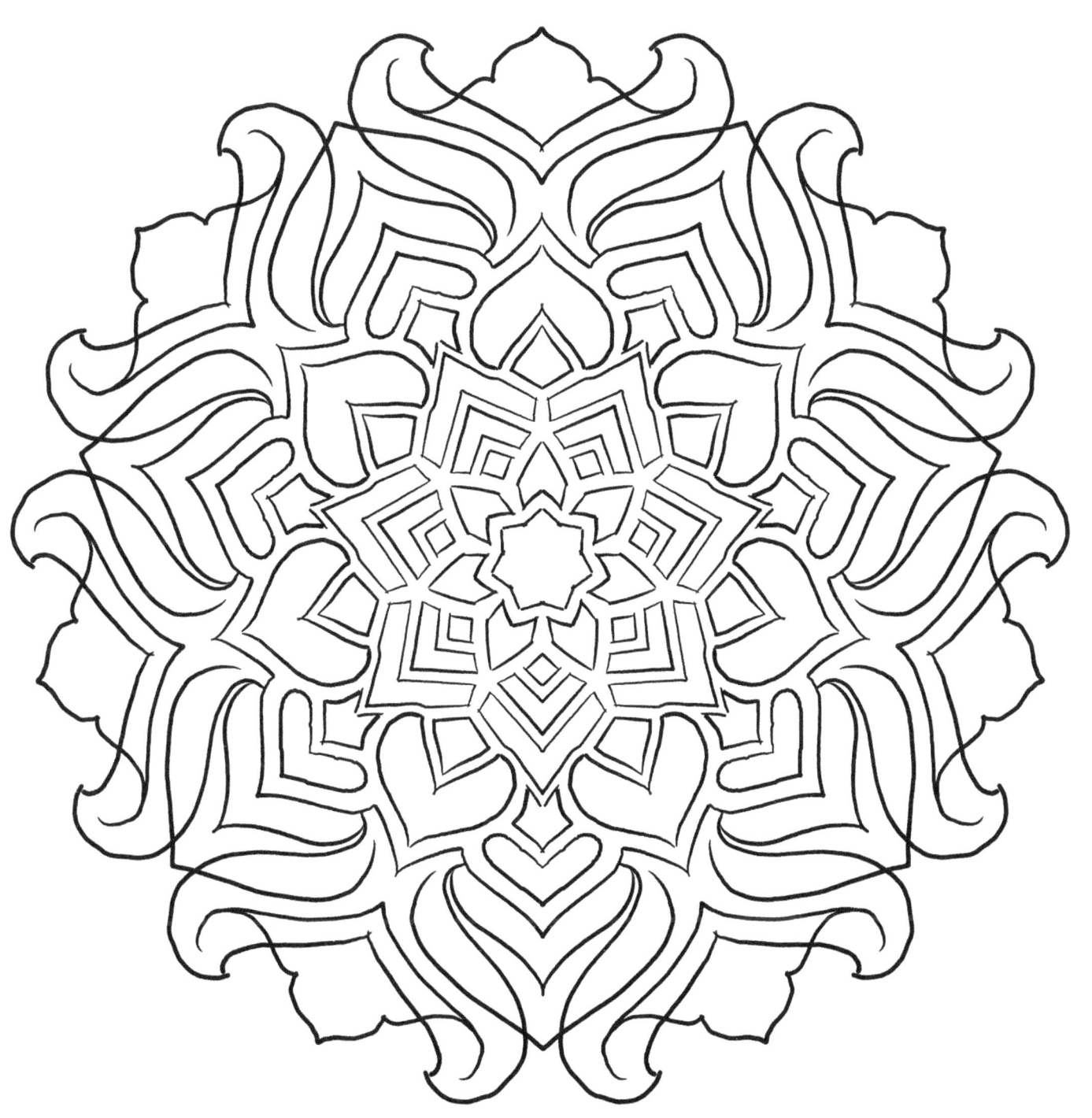

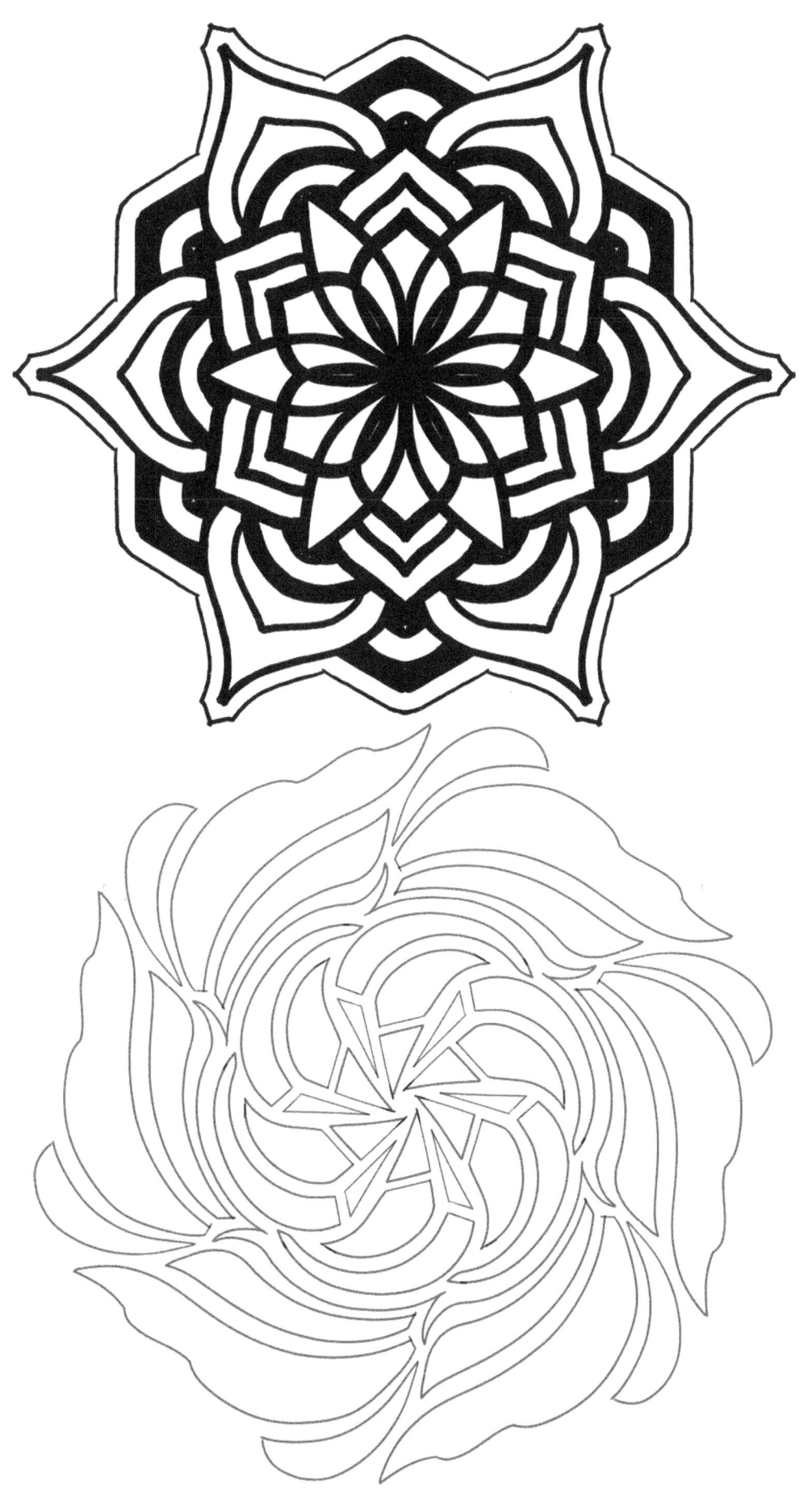

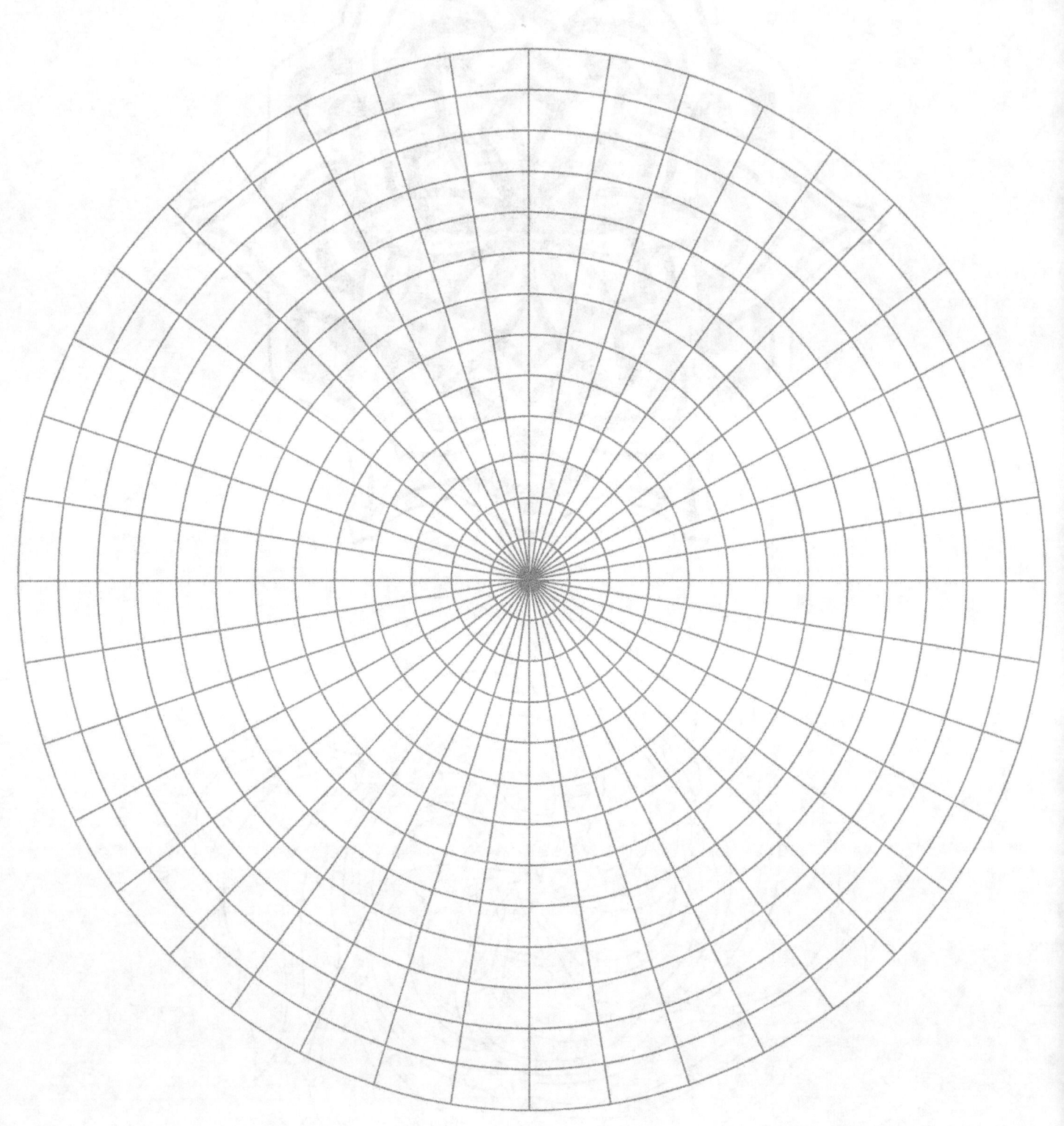

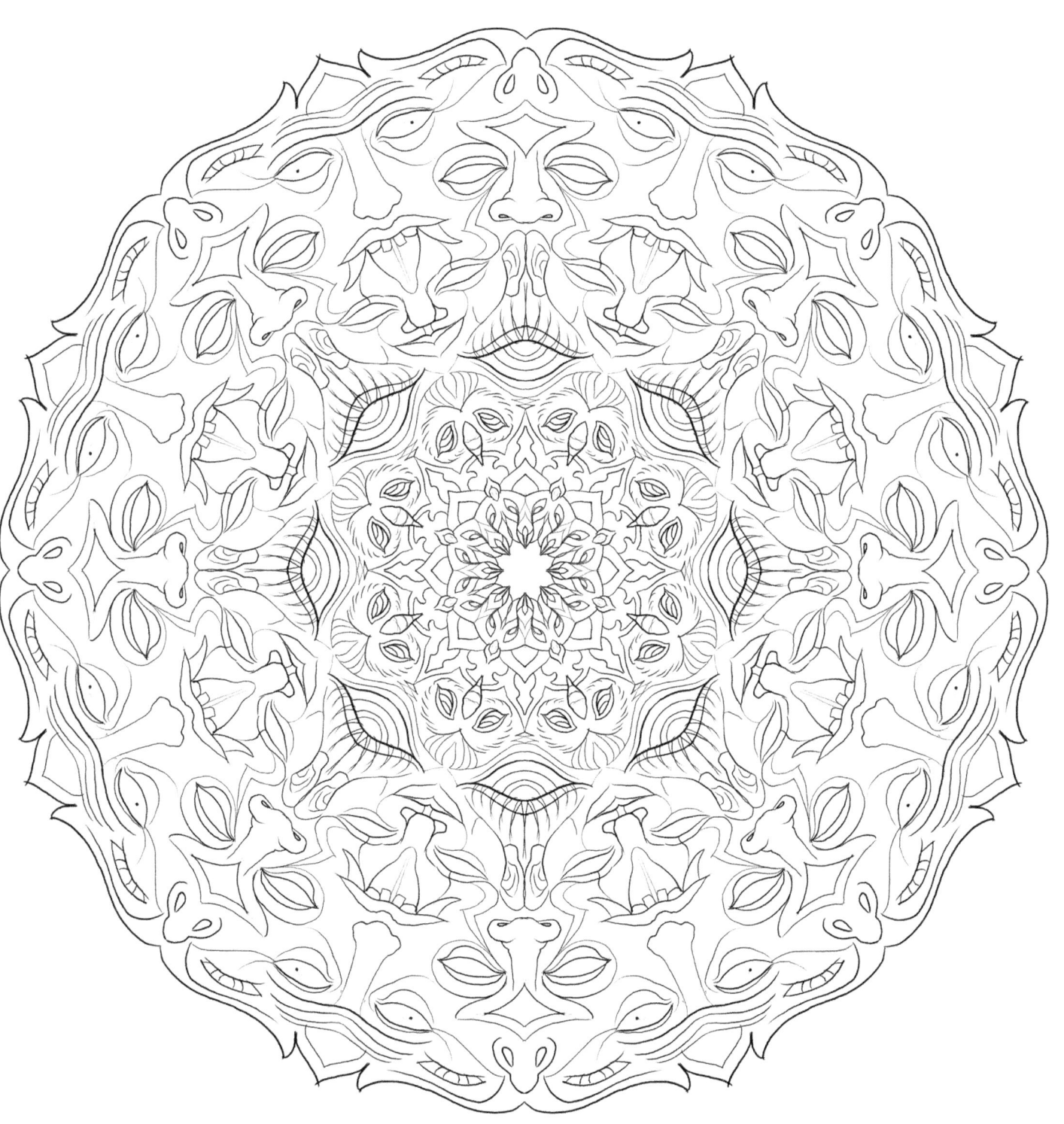

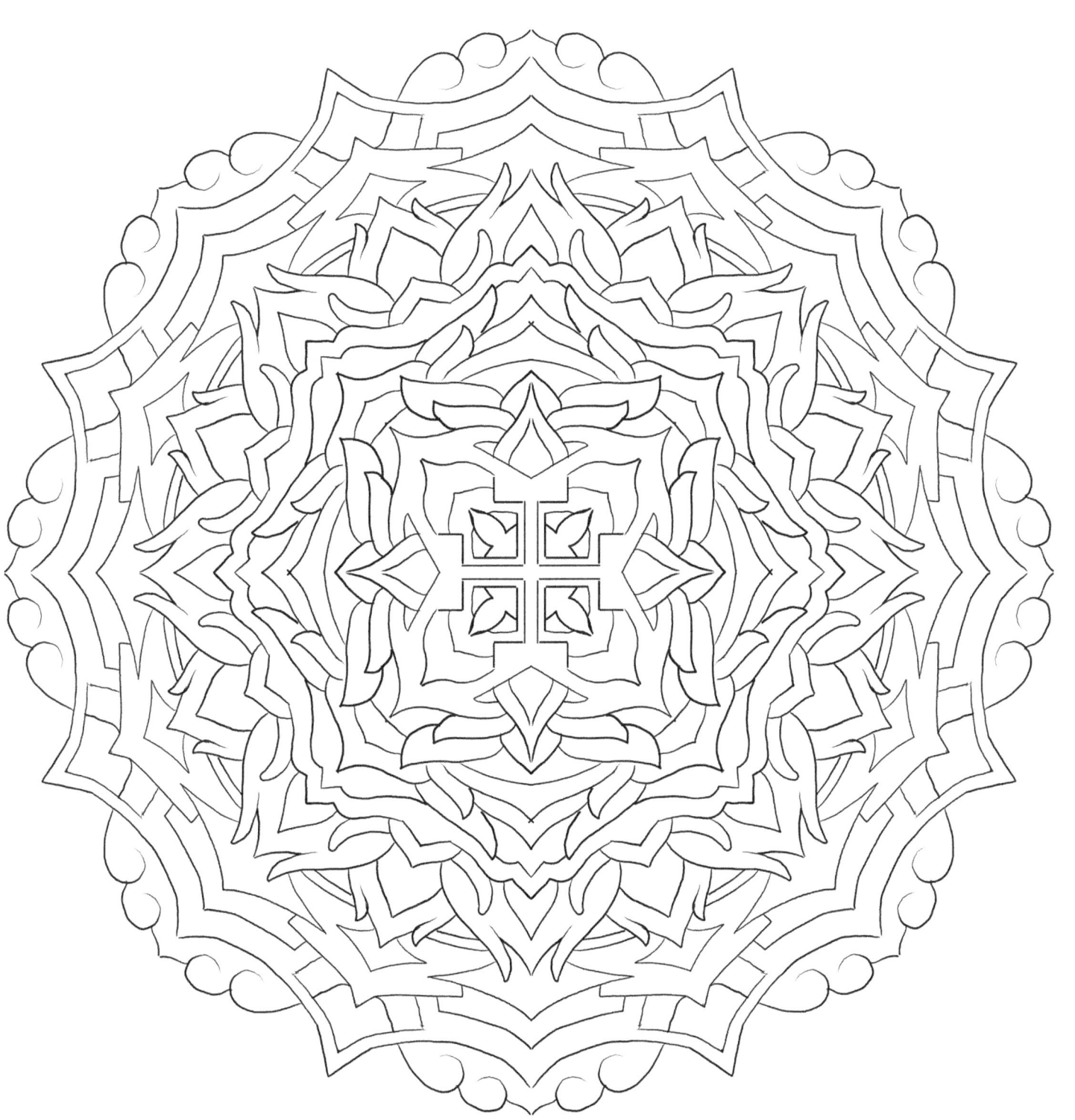

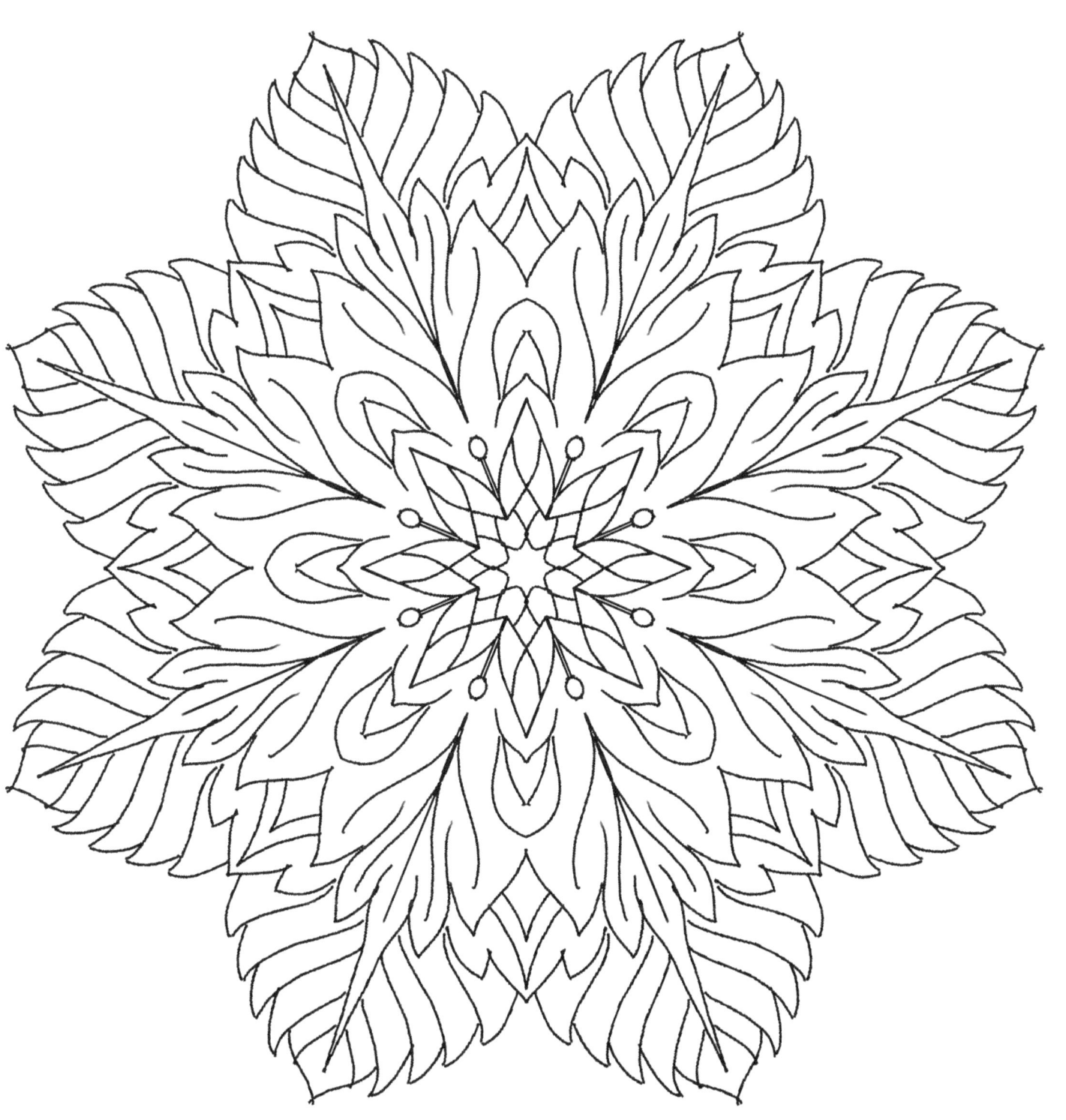

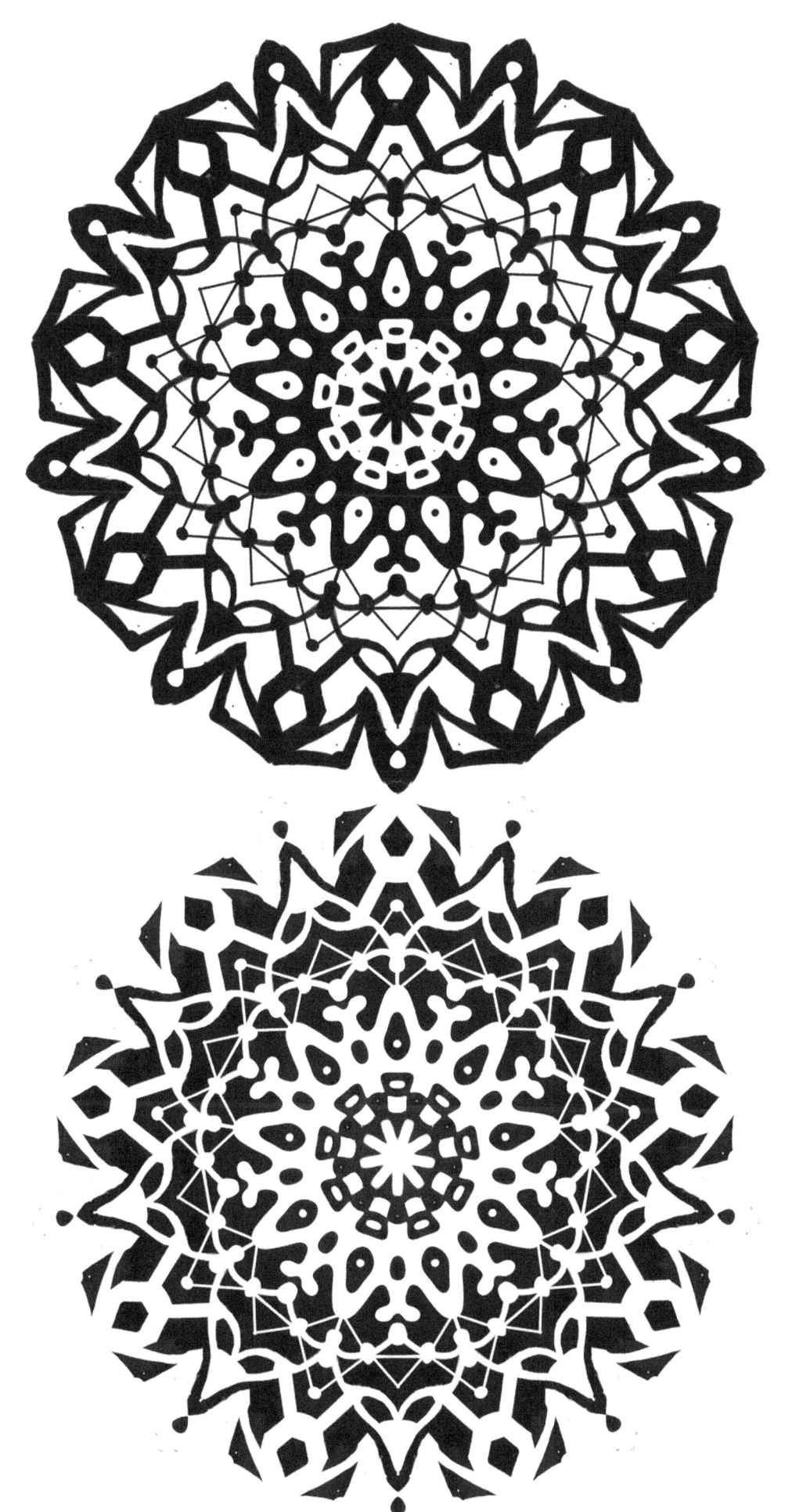

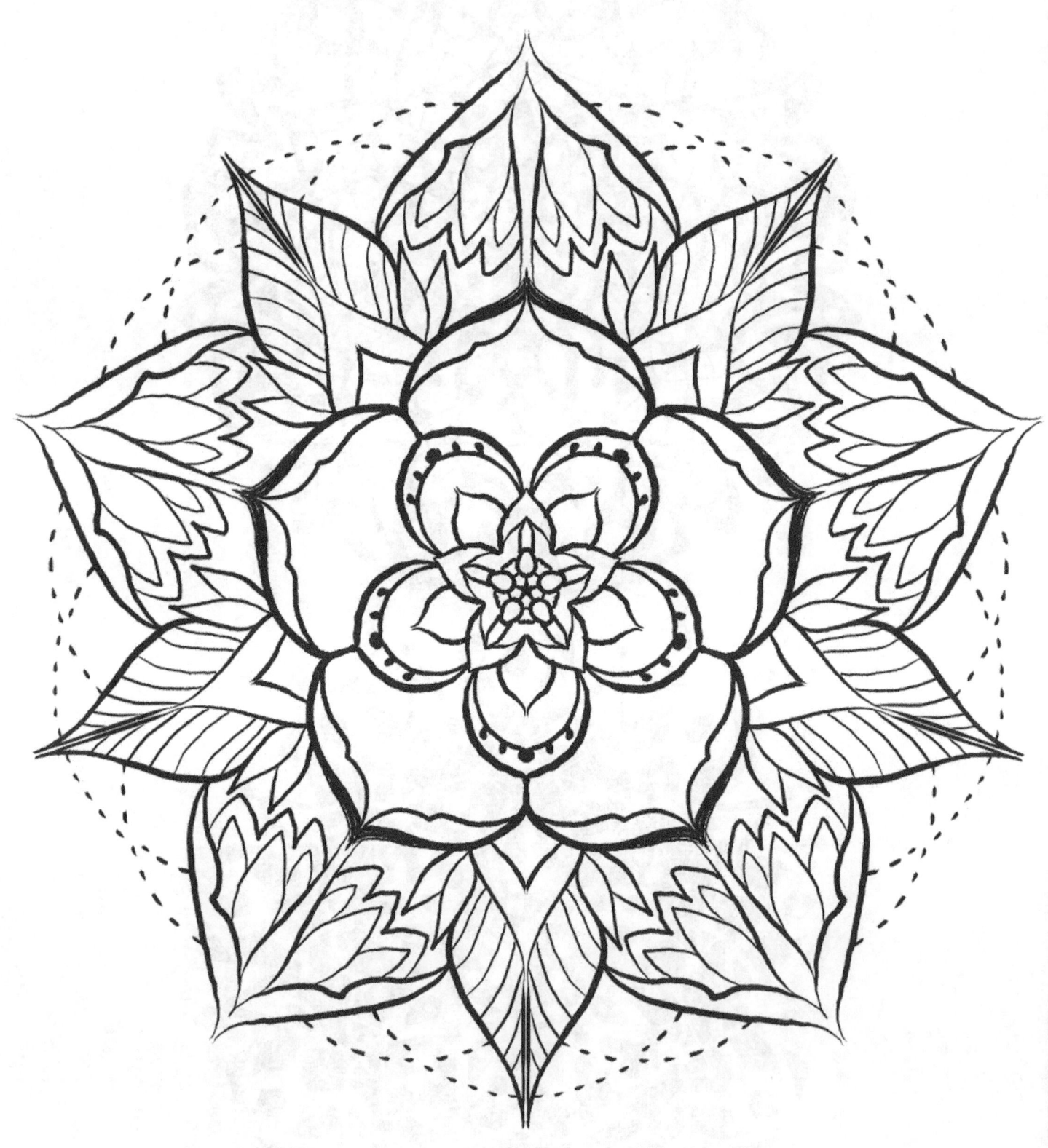

www.ingramcontent.com/pod-product-compliance
Lightning Source LLC
Chambersburg PA
CBHW080656190526
45169CB00006B/2139